Starting to paint still life

ND
1390
.D84
1979

Dunstan, Bernard,
1920–

Starting to paint
still life

DATE DUE

JUN 2 6 2006			
SEP 1 1			

ND
1390
.D84
1979

LIBRARY/LRC
OUACHITA TECHNICAL COLLEGE
P.O. BOX 816
MALVERN, ARKANSAS 72104

Detail from *The Ambassadors* by Holbein

Starting to
paint still life

Bernard Dunstan

Studio Vista, London
Taplinger/Pentalic, New York

LIBRARY/LRC
OUACHITA TECHNICAL COLLEGE
P.O. BOX 816
MALVERN, ARKANSAS 72104

First published in the United States in 1979 by
TAPLINGER PUBLISHING CO., INC.
New York, New York

Copyright © 1979 by Bernard Dunstan
All rights reserved.
Printed in Holland.

No part of this book may be reproduced or transmitted in any form
or by means, electronic or mechanical, including photocopy,
recording, or any information storage and retrieval system now
known or to be invented, without permission in writing from the
publisher, except by a reviewer who wishes to quote brief passages
in connection with a review written for inclusion in a magazine,
newspaper or broadcast.

Library of Congress Catalog Card Number: 79-63841
ISBN 0-8008-7383-1

Contents

Introduction

A still life is simply a painting of objects. It differs from other forms of figurative painting only in that the subject cannot move (unlike a portrait or a figure subject), and is close to you (unlike a landscape). Apart from these obvious characteristics, the way you set about painting a still life is entirely dependent on your approach to painting generally.

This is something no book can tell you much about. One person will be fascinated by delicate and subtle shapes; another will see his subject matter from the point of view of colour, or pattern. No one can learn to paint from a book; but where a book may help is by opening one's eyes a little about the many possible ways in which a particular area of subject matter, such as still life, can be tackled.

In order to do this, it may be helpful to begin by getting rid of preconceived ideas about the subject. Still life is particularly hedged about with certain associations. In art schools it has been regarded for a long time as a convenient subject for beginners making their first attempt at a painting. It is, of course, ideal for this purpose. The subject neither moves nor changes appreciably, and is comparatively easily grasped. But the effect of this has been to fix the idea of still life as a mere exercise in many peoples' minds. So we have arrived at the paradoxical situation in which a subject that gives more scope than almost any other for personal predilections has become limited and codified to such an extent that one student's still life looks remarkably like another; and most people, asked to arrange a still life group, will come up with almost the same arrangement of bottles, apples and cloths that thousands of students have painted before.

The interesting thing about this conventional approach to the subject is that many still-life paintings of, say, the seventeenth century seem to us quite strange and inventive. It is really since Cézanne that the elements thought proper to a still life have been so limited.

Anyone who went to an art school in the old days will remember the activity known as 'setting up' a still life. Dusty bottles and a few pieces of drapery were got out of the studio cupboard and pushed around on a table until the student felt that something paintable had been achieved. I well remember my own first art-school painting. A piece of blue cloth was arranged in sweeping folds, obtained by pinning it up in a complicated and unnatural way over a drawing board; against this were placed a Spanish earthenware jar, a pound of green apples, and two bottles, one on its side.

Fig. 1

No particular liking for these objects was involved; they had no natural relationship with each other; and few surprises could result from such a made-up composition. The results of this attitude towards still life were usually very dull, in spite of the value of the practice gained.

I am inclined to think that an exercise needs a more definite intention to be worthwhile or interesting, and later in this book we will be considering still life from this point of view—as a way of finding out something about painting by setting clearly defined problems.

Even on the simplest level, of getting some practice in painting, far more can be done with a subject that strikes some spark of interest in the painter. Still life is as good a way of learning how

to paint as any, and a better way than some, but it is much more than that. And learning has a way of being more productive in direct ratio to the learner's involvement and enjoyment.

So let us consider some of the pleasures of still life, and some of the ways in which it is different from other subjects, and thus requires different mental approaches from the painter.

As I said before, still life is the only branch of figurative or realistic painting in which everything absolutely everything—is under the direct control of the painter. When you are painting a portrait, the sitter is bound to move a bit and look slightly different at consecutive sittings. Also he or she is likely to have some impact of personality which may or may not have a good effect on the picture. A landscape alters even more, from minute to minute perhaps, with the light and the sky, and working outdoors brings innumerable distractions.

A still life makes no demands. It stays put hour after hour, day after day. As we saw when glancing at that dull art-school still life, this very controllability has its own drawbacks, in simply not making enough of a challenge. Compared with the keyed-up tension of painting other subjects, it is inclined to make the painter mentally go to sleep, still moving his brush. But this immobility can be a blessing, allowing one to concentrate more completely than any other subject.

The undemanding quality of still life makes it very important, I think, that the painter should feel the charm of his subject matter strongly. Perhaps no one will succeed in painting still life with intensity unless he has a love for actual material quality and substance. On the other hand, perhaps everyone should at some stage paint still life in the hope of disclosing some unrealised sympathy with the world of inanimate objects. The things one paints can be of almost any kind, once one gets away from preconceived ideas: stones, shells, biscuits, lobsters, ribbons, tea-tables and kitchen sinks, shoes, matchboxes, cakes, crumpled paper, as well as the world of beauty contained in the kitchen cupboard. All have, in some degree, a personality—a beauty of form, a quality of colour and texture, a way of taking the light.

Perhaps personality is the wrong word to use. What I am talking about is the essential quality of things. An appreciation of this can make a still life more than just an excuse for a nice bit of painting. The recognition of this quality is something which all the great painters of still life share, from Chardin to Braque; and, further back, the Dutch and Flemish painters, and such great masters as Velazquez, who painted no self-contained

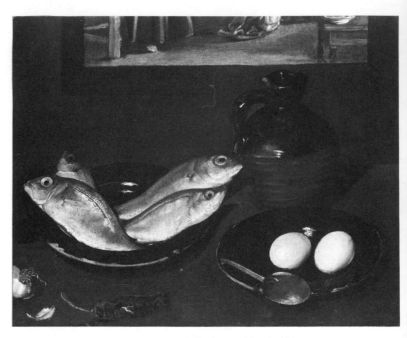

Fig. 2 Detail from *Christ in the House of Martha and Mary* by Velazquez

pictures of objects on their own but who have left some of the greatest still lifes of all tucked away in odd corners of their pictures, like this detail from Velazquez's *Christ in the House of Mary and Martha.*

It is a temptation to try and sum up some of the qualities that a painter of still life needs to have. Running through a list of the great names—Velazquez, Chardin, Cézanne, Manet, Morandi, Braque, Bonnard—I think we might conclude that they all have in common an unshowy quality—a love for solid and substantial surface and plain things. They are all painters who are more likely to be attracted by the crust of home-baked bread than by the sheen of satin. You could call it a sense of the magic of ordinariness.

Along with this, there seems to be an attraction towards stability and stillness in design. The tradition of still-life painting has little of the Baroque about it; it belongs rather to what the French call 'La Bonne Peinture'—a concept of art that is nearer the kitchen than the drawing-room.

1 Some practical considerations

There is a lot to be said, I think, for the attitude of an old painter I know. 'There's only one way to learn to paint', he said; 'Find out what you like; paint it as well as you can; and go on doing it, over and over again.'

Without the essentials contained in his advice, certainly nothing that we get taught is going to do us much good. And the technical side of painting can similarly be simplified. Stated baldly, it is no more than making marks with colours that will stick to a support. However much we study – and it can be a fascinating subject – about varnishes, media, grounds and pigments, the point is that masterpieces have been painted with the very simplest means. What could be more direct than Corot's method, for example? Many of his landscape sketches – among them some of the masterpieces of European painting – are done on paper, and the paint is applied in the simplest possible manner.

However modest Corot's means, they were ideally suited to his intentions, and this is really what technique is all about. Having satisfied the first elementary considerations, that the paint should mix together and dry without trouble, and will stick to its support, the important thing is that the materials we use should suit what we are trying to do.

Colours don't present much of a problem. All modern tube colours are reasonably safe, and similar in handling properties. (I should mention here that I am talking about oil painting in this book; this is partly because I use it exclusively myself, and partly because it seems to me to be ideally suited to the approach to still life that I shall try to explore.) So there doesn't seem much need to make lists of colours here. If you want to be sure that your pictures will last, the manufacturers usually supply a list, or mark the degree of permanence on the tube.

Still keeping to the idea of simplicity, I would suggest that you use no medium other than turpentine (familiarly called turps); home-made panels and canvases; and direct, unaffected surfaces of paint made with ordinary hog (bristle) and sable brushes.

There is one thing that needs to be said here in relation to still-life painting, and suiting the means to the ends. You may well be working on a rather small scale, or dealing with delicate forms. In a situation like this – the same would apply, of course, to painting a head – your brushes need to be sufficiently flexible and varied to ensure that you are not in any way restricted to making a particular kind of mark. To use only a few large stubby brushes, or only a palette knife, is rather like a carpenter restricting himself to one big blunt chisel. Yet it is remarkable how many

people will limit themselves in this way, from an idea that they will be able to work freely and without 'niggling'. In fact a too limited choice of brushes is more likely to result in a monotonous and coarse surface, which is far worse.

You don't need a large number of brushes, though you will probably collect quite a number as you go on working. I would suggest having several hogs (bristle brushes), both round and flat, with quite long, flexible bristles. The shape known as filbert is very useful, and some round brushes are also essential. Here, merely as an example, are the brushes I was using this morning for a small picture. Some are more worn than others.

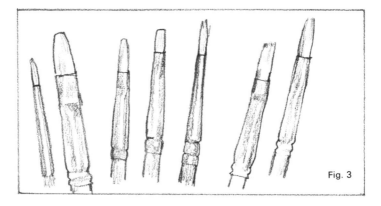

Fig. 3

The important thing about using reasonably small and flexible brushes is that it is quite natural to use them for making what we could call a 'drawing' mark, as well as for putting down an area of paint. It is surprising to find out what sensitive and precise touches can be established with a hog (bristle) brush—in fact it will probably hardly be necessary to use sables at all. I always have one or two sable brushes handy, but often find I am using them only for signing pictures!

For the same reason—the ability to make a precise statement—I would suggest using fairly smooth panels (hardboard or masonite) or canvases, though obviously the sort of surface you use must depend on the sort of painting you want to do. An attractive surface that you really enjoy painting on is a tremendous help in getting any picture going, especially in the case of the still-life subjects on a relatively small scale that we shall deal with here.

If you can make your own panels, so much the better; you will then be able to cut them to any shape or size that you want. It is a pity to be limited to manufacturers' stock sizes—you might want to use any shape, from dead square to long and thin. This applies to canvases as well. You will be able to find details of the preparation of grounds, and of making panels and canvases, in many books—such as *Starting to Paint Portraits* published in the same series as this book—so here I will only make one or two suggestions.

The most straightforward primings are gesso (a paste made of chalk and size), oil undercoating (usually white lead), and acrylic primer. Gesso is cheap and easy to prepare, and dries quickly. It has a rather dry, absorbent quality. Any oil undercoating tends to be smoother and less absorbent. It should be preceded by a coat or two of rabbit-skin glue size to seal the surface, then allowed to dry out thoroughly for some weeks before being used. You should be sure that your paint is of good quality, like that called white lead in oil. Most of the commercial undercoatings are doubtful from the point of view of lasting permanence.

Acrylic primer (also known as hardboard primer in Britain and acrylic gesso in America) can be used on any surface without previous sizing. It dries quickly and can be painted on almost at once, but it is very expensive compared with other grounds; and I find it a slightly unsympathetic and lifeless surface to paint on.

You must experiment: try all the possible supports and primings until you find what really suits you best. The only thing that matters, apart from permanence, is that the surface should work *with* your painting and not *against* it. It is surprising how the deficiencies of a panel—slipperiness, harsh raw surface, excessive absorbency—can alter the whole course of a painting.

Canvas is still, to my mind, the most attractive surface of all. You will need to keep a number of stretcher bars in stock, so that a canvas of any shape or size can be made up easily.

Although, as I said earlier, I am confining myself to oil painting in this book, there is no reason why any other medium should not be used for still life—the acrylic media, gouache, or a mixture of one of these water-based paints with chalk or pastel. The only medium that I' would not recommend personally is pure watercolour. This is very difficult to handle, as it does not permit the continual alterations and adjustments that are implied in the sort of objective study that we will be most concerned with in this book.

2 Drawing

This cannot really be separated from painting. Any mark you make with a paint brush is a statement about form and shape, as well as about colour and tone. Even if all you do is to scrub in an area of flat colour, it is bound to have a shape of some kind.

Fig. 4

So, for our purposes, we can think of drawing as simply as that—getting the right shapes in the right places.

The shapes that we put down, whatever their nature, have got to have a certain precision. That is, they must go where we want them to. This applies just as much to a 'freely' painted picture as to one with sharp edges and clearly delineated forms. The painting by Bonnard, on p. 15 (Fig. 5), is as precise, in this sense, as is the Flemish still life on p. 78 (Fig. 70). The precision, in the Bonnard, lies in the relationships, rather than in the separate forms; but as well as the relationships of colour, which are obviously very exactly considered, the quality of these loose and free edges, these apparently casual groupings, can only be termed precise in the way that the artist's intention has been exactly carried out.

So precision doesn't mean niggling; it exists in all painting and drawing that works at all, whether the idiom is tight and neat, or free and 'painterly'. These distinctions don't really matter at all.

However, it does seem natural for a beginner to start painting with a certain hard, 'edgy' quality. The early work of nearly all the great painters has something of this clarity and sharpness, even when they have developed a very free handling later. There is nothing to be ashamed of in precise and detailed handling. Many amateur painters are quite unnecessarily afraid of this, to such an extent that they often regard all detail as something to be avoided at all costs. Yet detail only means small forms, which often cannot be left out or reduced without altering the character of the bigger shapes.

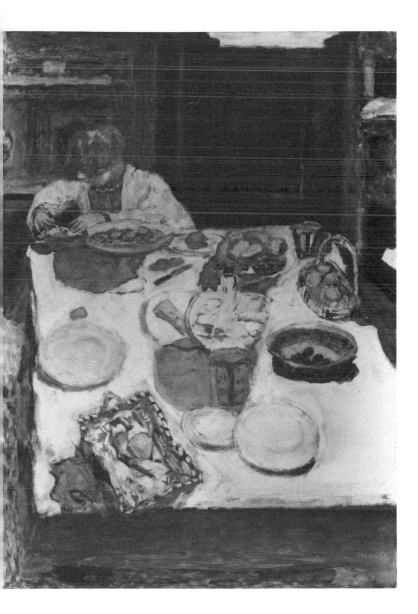

Fig. 5 *The Table* by Bonnard

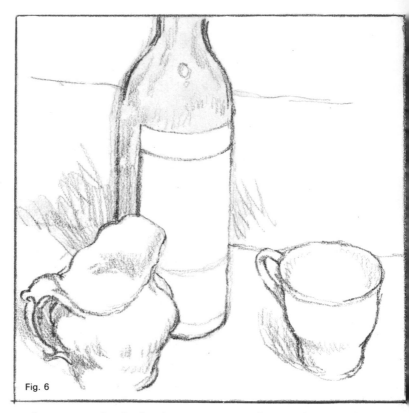

Fig. 6

As an example of what I mean, suppose that you have a wine bottle with a label among your group of objects. What do you do with the lettering on the label? Some painters, regarding this as coming into the category of unnecessary detail, would leave it all out and reduce the label to a mere white patch; see the drawings on this page and the next (Figs 6, 7). This would surely be rather like leaving out the features in a face. The mouth and eyes are only small forms, too, but they obviously play an important part in the human head!

Small forms describe, decorate, and give point and life to the big shapes, which can become merely empty without them. This would certainly apply to the letters and shapes on our wine label. A blank white patch is not at all the same thing, and moreover it may falsify the tonal values of the whole of this area. So something has got to be put in. Whether the letters are drawn clearly, or only hinted at, must depend on the sort of painting that you are doing, of course.

16

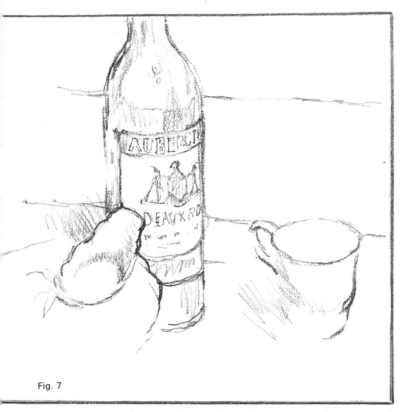

Fig. 7

This is a simple example to show that we must be on guard against sweeping generalisations about what is important and what is not. I would go so far as to say that in the average still-life painting it is better to try and use everything that you can see, down to the smallest forms which are still manageable with the brushes that you are using. You are far more likely to make something interesting out of what is there than if you leave out everything that doesn't immediately appeal to you. Selection and simplification may be essential as you go further; but at first selection is better exercised on the choice of the subject and its placing in the picture space, rather than by arbitrarily omitting things. And simplification can be exercised in the attempt to make your statements as simply and as subtly as possible, without exaggeration of tone, colour or brushwork.

A simple still life, more than any other subject, can give you the opportunity of really going deeply into problems of relating colour, tone and shape. It is the best possible training in observing,

analysing, deciding what you are doing, and doing it with intention and precision. This list covers a lot of what painting is about; not everything by any means, but I am sure that this sort of objective study is still the best basis for a painter's development.

Whatever kind of picture you want to do, I am sure you will find that some objective painting of still life will sharpen your sensitivity to form and colour, through a close observation of static forms and their relationship to one another.

By objective painting I mean painting in which observation is more important than style.

Observation, in this sense, is the enemy of generalisation. Take the most simple subject possible—three or four small shapes, such as sweets, scattered without any arrangement on a table. A generalised statement about the placing of these forms would be satisfied with 'getting it roughly right'. But it is worthwhile not remaining satisfied with this, and trying to relate distances and shapes as exactly as possible—getting, for instance, A to B as right as you can in relation to B to C. This is not because there

Fig. 8

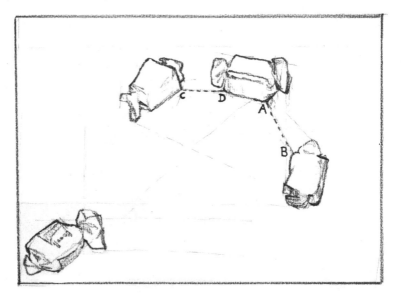

is any particular virtue in measurements, but because the sheer effort of relating and checking them will make you look harder, and give your drawing far more intensity than a merely 'near enough' attitude.

In just the same way, you will get more out of an attempt to see the exact colour relationship between the objects and their setting. Other things can come later, and will be more likely to mean something if this basis of exactly-observed relationships lies behind them.

So this is all I mean by drawing in this context—closely observed relationships of shape and distance. As I said before, this should be going on all the time one is painting, so don't think of drawing as something that takes place only when you have a pencil in your hand.

All the same, it isn't at all a bad idea to get into the habit of making little pencil notes, at odd times, of bits and pieces around you, trying to do little more than accurately estimate distances and directions. It will help to sharpen your perceptions, and will encourage the habit of looking with a measuring eye—which is to say an eye which doesn't only look at one thing at a time, but at the relationships between things as well.

As an example of the sort of thing I mean, which could be done at any odd time of the day (this one took exactly five minutes), here is the first thing that caught my eye when I looked round from the typewriter.

Fig. 9

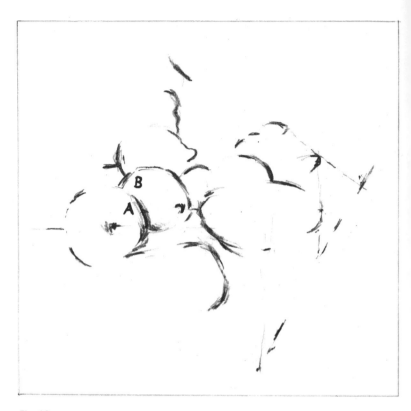

Fig. 10

This drawing is a little more elaborate, but you can see that the method of procedure is very much the same. I show two stages (Figs 10, 11), to make it clearer how a drawing can begin at any point and simply develop outwards, so to speak. This study did not even start from any particular identifiable form, but from a bit of one shape in relation to another (A−B). Straight away gaps and distances are being put down, and not only separate forms.

The angle of the table top is related, from the beginning, to the other forms. You will see how a line has been dropped from various points (this is known as plumbing) to establish where this angle comes below them. Perspective is thus arrived at, without any preconceived or theoretical basis, but purely by observation.

I am not by any means holding up this sort of drawing as a general method; it is simply useful as a way of seeing the subject as a whole.

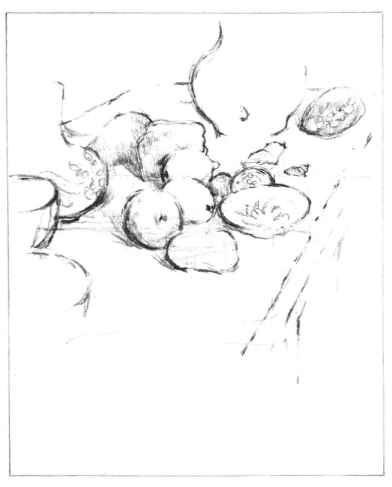

Fig. 11

The drawing proceeds as an additive process. But it should always be possible to go back and recheck distances and angles.

In fact, if you use this approach to drawing, you are doing something that is not very different from what goes on in the course of a painting. The drawing is likely to be more linear, the painting more a matter of masses; but it is quite natural in a painting to jump about from one thing to another, to do a bit here and. a bit there, and to be more conscious of relationships than of individual self-contained shapes.

One or two other points about drawing, which apply particularly to still life, may be briefly considered here.

Elliptical shapes, like those in the drawing we have just discussed, often give trouble. Again, we can best approach this problem simply by using our eyes — by straightforward observation, rather than by using theoretical solutions. A subtle shape like an ellipse can be made easier by checking from different points around it. Instead of trying to draw it with one sweep of the wrist, as a self-contained shape, it is often easier to build it up, so to speak, in segments.

Start with a part which can be related to something outside itself, but nearby (Fig. 12). This might be a knife, or the edge of the table, whose direction runs alongside one part of the ellipse.

Having established this bit, you could then jump across to another part, and put down the angle that it goes at in relation to another form (Fig. 13).

Gradually the whole shape is built up, by an aggregate of separate acts of observation, and in the process of doing this you find that you are not only drawing the ellipse, but are relating it to surrounding shapes.

This way of piecing together the form, of approaching a big shape by means of the small ones, is likely to happen when we tackle the placing and construction

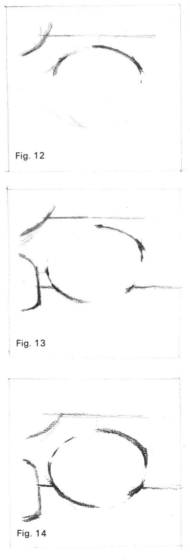

Fig. 12

Fig. 13

Fig. 14

22

of a group of forms without any preconceived ideas; using observation of whatever happens to be there in front of us, and without falling back on any generalisations or theories.

I must stress again that I am not concerned here with any hard and fast method of drawing. But I suggest that when working from nature it is a good principle to particularise, rather than to generalise.

By generalisation I mean a diagrammatic and simplified approach to form which can often prevent us from looking for ourselves. An example of this is the principle that used to be recommended in 'how-to-do-it' books and articles, that all forms can basically be reduced to a sphere, a cone and a cylinder; thus an apple is in essence a sphere, and a bottle can be constructed from a basic cylindrical shape.

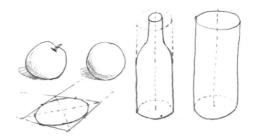

Fig. 15

Such basic construction might be useful if we were inventing pictures out of our heads. But still life is, more than any other subject, something that we are going to have in front of our eyes all the time we are painting, and so it seems much more to the point to train our powers of observation on the whole thing in front of them.

In an article I was reading the other day, I came across the advice that one should leave out cast shadows. This is a very good example of simplification and generalisation taken to absurdly dogmatic lengths. In any case, if one is to leave them out, what does one put in their place? Presumably something would have to be made up (or fudged up), but the trouble here is that in most cases nothing that one could invent is likely to be half as interesting as the way that things 'just happen'.

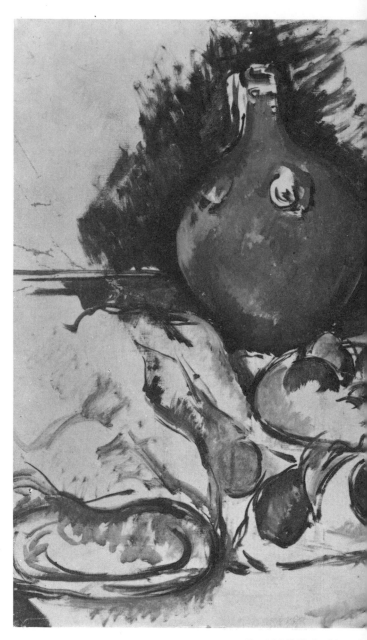

Fig. 16 Still life by Cézanne

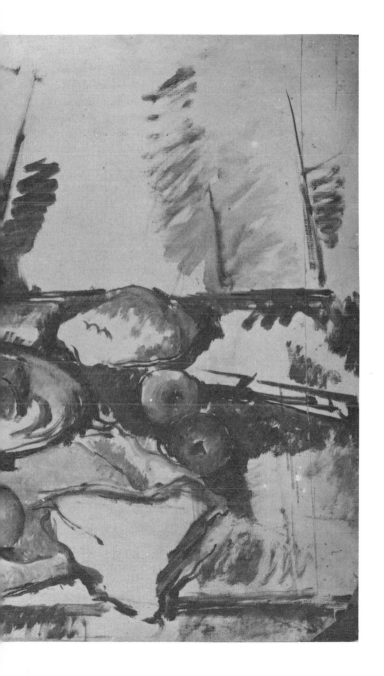

3 Different kinds of still life

The distinctions that I want to make between different forms of still-life painting are not concerned with how the picture is finally painted, but with the difference of approach to the subject. We could classify them as the arranged still life, and the accidental still life.

The first is put together consciously. Selection and choice are exercised from the beginning—in the choosing of the objects, the grouping of them, the environment that they are going to be seen against, and so on. The accidental group 'just happens', and the selection comes in through the way that the painter sees something, decides he likes it, and chooses his viewpoint and format.

These two categories overlap, of course. The 'found' subject may in fact need a bit of pushing around before it is quite right, and the arranged one often gets its first impetus from something seen. Still, I think the general distinction is clear.

Most still-life paintings, and nearly all those of the past, belong to the first category. Examples in this book are the Morandi on p. 54 (Fig. 47) and the elaborate composition by Louis Finson on p. 78 (Fig. 70).

The casual, unarranged still life is a more modern development, and perhaps its greatest exponent is Bonnard. Over and over again in the work of this great French painter one finds delicious and strange still-life passages which look so fresh and casual that one feels they must have been picked out and used exactly as they were. A good example is the tea-table on p. 15 (Fig. 5).

Perhaps I should make a third category; the still life that is part of a larger composition, which may include a figure or figures. Some of the finest still lifes of all, as I have already said of the Velazquez on p. 10 (Fig. 2), belong to this kind; both the Bonnard and the Finson have a figure in them. I am not concerned here with whether they are properly to be labelled as still-life pictures or not. The still-life element is very important in them and that is all we need to be concerned with here. Chapter 7 (p. 75) will deal with this important category.

To return to the first two kinds of composition, the consciously-arranged and the casual or accidental, I would like now to take each in turn, discuss its special character and difficulties, and describe briefly the development of a painting of each kind, illustrating one or two stages in its progress.

4 The arranged still life: experiments in design

Cézanne used to spend hours arranging his groups. He would use coins to prop up the apples to just the right angle, turning and tilting each one until it made the right colour relationship with its neighbours. Presumably other elements, such as the direction and pattern of folds in a cloth, would be given the same attention.

This laborious arrangement is completely in tune with his slow and deliberate way of painting. It needs to be done, as he did it, with a rather clear idea of what is aimed at; otherwise it can go on almost interminably, through innumerable small and arbitrary changes.

Conscious arrangement seems to imply a conscious purpose. I don't necessarily mean that the artist must have a clear idea of exactly what the picture is going to look like; I mean rather a sense that there is a definite theme, that the picture is going to be dominated by one element or another.

The possible choice of subject matter is so unlimited that I would recommend a conscious limitation. Choose things that seem to belong together, and cut out inessentials—particularly those purposeless additions which tend to be put in merely to fill the composition out into the accepted image of what still lifes generally look like. Be firm, and include nothing which doesn't seem to you essential.

Let's start from scratch. If nothing else suggests itself, go into the kitchen. This is an unfailing source of beautiful objects. A good picture can be made of very little actual material; and so, with the intention of choosing things which have a positive relationship and a natural point in being together, we could do worse than find our motif in the materials for a meal. What are you going to have for lunch, for instance? A boiled egg? Well, that gives us straight away the beautiful homely fresh colours and textures of eggs, bread, and butter. This is quite enough. Chardin needed no more to create a masterpiece.

It might be worthwhile to use this very simple material as the basis for some experiments in design. The possible permutations, of course, are infinite, and here we will only be exploring within a limited range of possibilities. There are seven separate objects here: two eggs, an egg cup, a loaf of brown bread, a pat of butter in a white dish, and a knife and spoon. Put down on the kitchen table exactly as they came from the cupboard, they made a row or line and looked rather like this (Fig. 17).

If we put objects down in a line they often look very attractive. One's eye runs along the succession of varied shapes, from one colour to the next, appraising each one in turn. It is like making

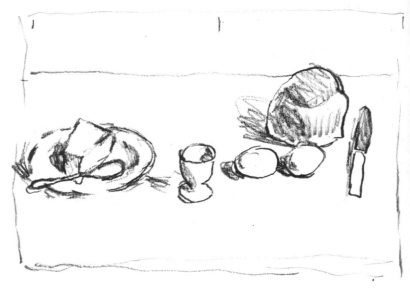

Fig. 17

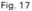

a list of the objects.

Now I believe very strongly that things don't get put down on a table, even in the absence of any conscious thought, without some natural and inevitable order taking place. In this case, what attracted me was the blond and fresh colour of the objects, and the fact that there was not any great difference of scale between them. Each one had a certain precious quality, and I am sure that this had an unconscious effect on the way I put them down to look at them. So the idea of the row, or line, of objects came in right at the beginning, and the subsequent arrangements were all variations on it.

I think this awareness of the first, unpremeditated, way that things seem to arrange themselves is very important. It links up with the idea I talked about earlier, of retaining a theme for your group and not losing sight of it. In this case, as I said, the theme is related to the ideas about colour that the objects gave me.

The first group, then (Fig. 17), is a beginning; but it is a little monotonous, certainly. Perhaps we could start our arranging by making the gaps or intervals between the objects more varied.

28

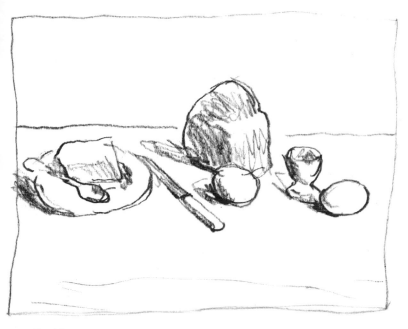

Fig. 18

You will notice here that I have slightly increased the scale of the objects, as well. They now fill the space better, but they still occupy their rectangle in rather an equal way. For instance, the space above and below them is about the same, and the line of objects starts and finishes about the same distance from each side. The whole shape of the group perhaps makes too obvious a triangle, rising up to the highest point of the loaf and running down again to the eggs on the right.

So our next move might be to stick to the same general arrangement, but to alter its relationship to the rectangle (Fig. 19). We are now making an important decision—to cut off part of one of the important elements in the design, the butter dish. This is important because not only does it again increase the scale of the objects in relation to the frame, but it changes the round or elliptical shape of one of the largest things in the group. The triangularity is still there, but cutting off the left hand side makes it less obvious. At this stage, though, I became aware of two new and slightly distracting points. The loaf is now almost exactly in the middle of the rectangle, and the knife makes a diagonal which

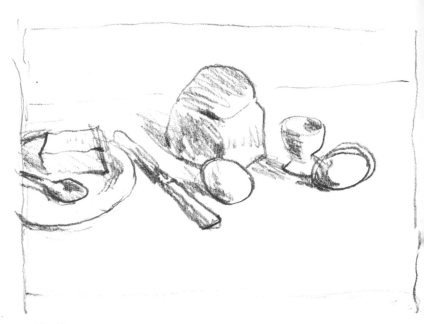

Fig. 19

is very similar to the other line running from the top of the loaf down to the egg at the right hand side.

Neither of these points need to be made too much of. There is absolutely no reason why an important part of the picture should not be slap in the middle, if that is where it seems to belong, and parallel directions, the echoing of one angle by another, can be of the greatest use in binding together the component parts of a design. In this case, however, both these things happen rather too obviously, without making any very useful contribution.

So let's try breaking up the group still further, and in doing so we will try to make the spacing a little more varied (Fig. 20). We now have two separated groups: the bread and the butter dish on one side and the eggs and egg cup on the other, so that a new set of relationships has been set up. But it still looks a little awkward — the group of the eggs, particularly, is cramped.

Fig. 21 shows a considerable change from the original conception. The arrangement has become much more compact, and relates now more to a square than to a long rectangle.

This would be a perfectly possible arrangement. It does, however, rather tend to 'go round in a circle'; also I felt that I did not want to deviate too far from the original long-shaped design. But we must not forget that every group we set up is only being looked at from one of the many possible viewpoints. It would

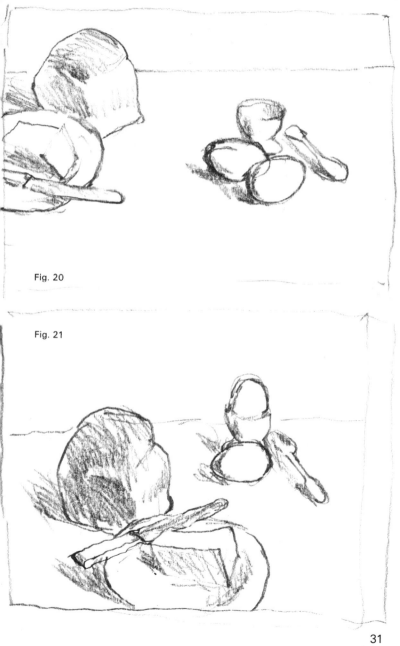

Fig. 20

Fig. 21

31

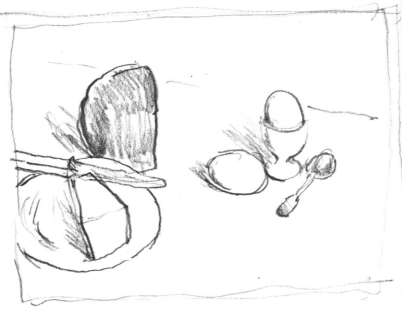

Fig. 22

have been possible to do ten drawings of each of these possible
groupings from different points of view.

With this in mind, a slight change of position to the right pro-
duced the final arrangement (Fig. 22). Notice, in these last two
drawings, the position of the knife and spoon. In Fig. 21 these
two straight shapes create a right angle; that is to say, if you were
to continue the line of the knife, it would cut against the spoon at
90 degrees. This, in spite of the tilted direction of the knife, gives
a certain feeling of stability, a geometric core, to the design. In
Fig. 22, though the angle is no longer a right angle, the op-
position of these two directions is still quite an important
element in the design, and it is linked with the definite per-
pendicular of the side of the loaf, and the other angular directions
made by the lines of the butter pat. The play between curved
and straight lines is another aspect of this linear construction.

32

All these things seemed now to be working fairly well, and so I felt it was time I started painting.

This is an example, a rather laboriously expressed one, of the way a design can be worked out in practice. You will notice one or two things which make this process a little different from most composition exercises. It is completely empirical—the design of the picture follows from the first impression of the actual subject matter. We have not been thinking at all in terms of abstract ideas— pyramidal shapes, golden sections, squares, diagonals or any other devices, except to get rid of them when they appeared to be getting too obvious.

Then the sense of the rectangle, which is bound to enclose everything that goes on in any composition, has been with us the whole time. Even the first drawing of the row of objects was set within a rough rectangular shape. This 'frame' is never a fixed proportion imposed on the group, but varies slightly from one arrangement to the next.

I think these points are worth stressing, and may be more important than they look. Composition is not a matter of rules and fixed proportions. It is something which grows out of one's responses to the subject, not something which is imposed on it.

And obviously there is no 'best' or ideal composition for a picture like this. Rather there are endless variations to be chosen from—a literally infinite number of possible pictures could be made out of these elements. Any of these would have made an equally viable basis for a painting.

A final word about drawing, before we move on to the painting. I would not normally make a series of drawings of this kind, for fear of dissipating the energy which ought to be going into the painting. One or two scribbles might be useful—but even then one would have to be very much aware that a preliminary drawing cannot be much more than a way of making up one's mind. It is more a note than a study for the picture. This is partly because no drawing can say anything about the different emphasis which is given by colour. For instance, in these necessarily linear statements, it is impossible to show that the butter is a strong yellow, the most energetic colour in the group. This is bound to make the actual shape of the butter much more important than it can be shown here. In other ways, too, a linear statement can be misleading.

So don't rely too much on a drawing; and if you do like to make preliminary studies, don't forget that everything is going to look very different when clothed, so to speak, in tone and colour.

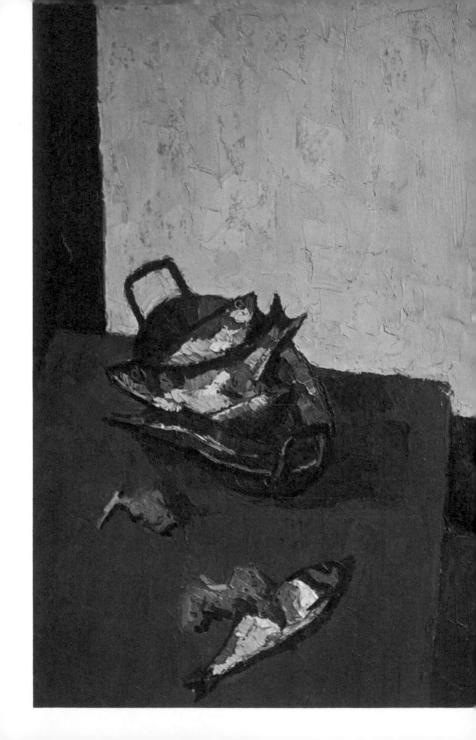

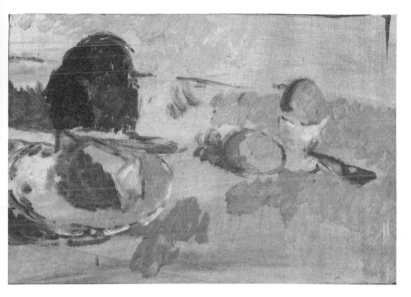

Fig. 24
(opposite) Fig. 23 *Still life with fish* by Kyffin Williams

The painting

For these reasons, I like to start on the painting without too much planning, and to get the actual picture going with the brush and with colour right away. This does not mean working hastily or unthinkingly. The process can be as deliberate as one likes. The important thing to me is that I should be using, as soon as possible, the means that are going to be used throughout the picture.

The illustration above shows the first stage of the painting. Although I had a fairly clear idea of the general design by now, I left myself with some room for modification by using a panel a little bigger all round than the final painting. I often do this when using panels, as it enables me to add on a little if the composition seems to demand it. The panel can be cut to its final shape later.

In this state the shapes have been directly drawn with the brush and the areas of colour are beginning to emerge. The colour of the table top, which surrounds all the shapes, is stated in a direct and simple way right at the beginning, so that as the more positive colours are put down, they can be related at once to their setting.

This was made even easier in this particular picture by the fact that the panel had a thin rub of colour all over it. The actual colour used for this tint was a light grey, and it was applied well before

the picture was started, rubbed over with a cloth, and allowed to dry hard. Painting on a tone like this, rather than on the bare white ground, has certain advantages; each touch of colour can be seen at once at its full strength, and the uncovered parts of the panel don't look so incomplete. The tone forms a continuity between the separate touches. For this reason it can help quite a lot when one is painting rapidly. On the other hand, I don't think I would recommend the use of a toned ground in every case. The dead white priming does give a greater luminosity to the colours, and also makes it a little more difficult to 'get away with anything'. Using a coloured ground can become a slightly obvious trick to give a false sense of unity.

There are obviously countless different ways of starting a picture, and any of them is going to suit someone better than any other. One painter will prefer to have everything worked out, as far as possible, before he starts; he may even begin with a careful drawing of all the shapes on the canvas. Another will prefer to let the thing grow from a few loose smudges of paint, always leaving himself room to manoeuvre and make alterations. One will finish a part of the picture and go on to the next; another will prefer to keep the whole picture going together, so that no one part of it is ever further ahead than the other.

None of these things matter at all. The less we can think in terms of fixed techniques, and whether one way of painting is better than another, the better. A painter's methods have to develop out of what he is interested in doing.

So these examples only give one way of developing a picture. As you can see, on the whole I prefer to keep the whole surface going, so that I can get an idea right from the start about what the construction, colour and pattern of the picture are going to look like. At the same time I like to be able to make drastic changes at any moment. I feel that every mark that goes down is modifying the total effect in ways that may be quite unforeseeable, and so one's idea of the painting can alter—sometimes subtly and some-times radically—from one minute to the next.

As you can see, this was not a painting that went through any drastic changes. The second stage, at which I felt it had gone far enough, was little more than a consolidation of the first stage. The building-up of the forms was developed through an accretion of small touches, placed on top of, or side by side with, others already made.

By the second sitting the paint had dried sufficiently for this to be done easily. I prefer not to work a great deal into wet colour.

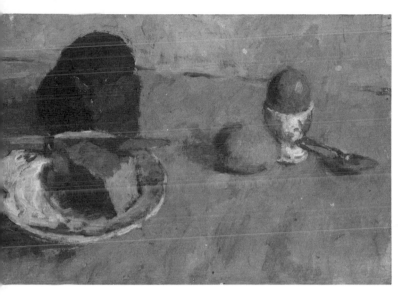

Fig. 25

The surface of the paint, after a period of an hour or so on a small picture like this one, can get into a state where subsequent touches begin to get bogged down or slither about. It is easy, if one gets on too long, to lose the freshness of the paint. If any big alterations have to be made at this stage, when you have wet paint all over the surface, it is better to take a palette knife and scrape down where you want to repaint, so as to come back to a fresher surface. But some painters are able to handle this problem more easily than others, and are able, apparently, to go on working into wet paint indefinitely.

For an examination of the way that one of the greatest painters of still life started his pictures, it may be interesting to look at the Cézanne on p. 24 (Fig. 16). This painting is particularly valuable to us as it is one of the very few by Cézanne which the master has left in an unfinished state.

A detail from the painting is given on this page. The first thing that we notice about it is the extreme thinness of the paint — probably thinned with turps—and the way that the picture has been started with a very 'open' and flexible drawing of the shapes on to a bare white canvas, using a fairly supple brush and a not very intense blue.

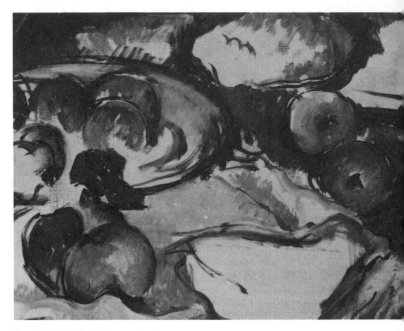

Fig. 26 Still life by Cézanne, detail

This drawing never goes further than an indication—slight, yet quite sufficiently definite—of the placing and shape of the objects. It is then straight away developed with patches of colour. There is, in fact, no break at all between the act of drawing and the act of painting; one continues directly into the other. Thus Cézanne will indicate the contour of an apple, or part of its contour, and immediately place a few touches of colour, defining the planes round its edge; these are linked up and related to a few other patches, which begin to establish the colour of a piece of cloth or a plate which comes near to it.

This process is going on over the whole picture. You can imagine his eye and hand moving about from one point to another, working for a time on one part—a pair of apples, perhaps

—and then leaving this area to look after itself for a time while he works on another part of the canvas.

There are a few places, however, where Cézanne has taken the statement of form and colour much further. The earthenware jug, and the pair of apples on the right, are both more fully realised than other parts of the picture. As the jug becomes more complete, it pushes out, so to speak, into the background area around it, which is beginning to be covered with dark patches and scribbles of colour.

Notice that he doesn't cover up the whole of this background area with a rub of colour to bring it to an approximation of its actual tone; he is not going to be tempted to put down any patch of colour that is not directly related to its neighbours. So the bits of dark wall go in only when they are sufficiently close to something else—in this case the jug—to be seen and understood in relation to it.

Gradually the canvas gets covered in this way, and then the process repeats itself, with more touches going over and between the existing ones, refining the gradations and enriching the colour. Cézanne himself said 'When the colour is at its richest, the drawing is at its most complete'; and all the time he is painting, the drawing of the forms is undergoing innumerable adjustments. His way of working combines the understanding and development of colour and form together more than almost any other painter's.

Cézanne's method with oil paint is very similar here to his use of watercolour; increasingly, in his later work, distinctions between the two media disappear. The thin, semi-transparent touches and washes of colour on a white ground give a beautiful luminosity to the colour. Even when a number of touches have been superimposed, something of this freshness remains, though, as the picture progresses, the paint would naturally become thicker.

It is worth mentioning that, from the point of view of permanence, this method of painting is ideal—there is not a crack visible in any Cézanne that I know of.

We can learn from this canvas, however far our own methods may be from Cézanne's. His is an extremely, almost obsessively, slow and deliberate way of painting, in which every touch is considered. But even if one uses a far more summary tempo of painting, one can try to relate the coloured patches together with something of this intense observation. As always, it isn't the actual method which matters—it is the way of looking.

5 Different sorts of composition

Before we go on to consider the possibilities of the unarranged or accidental still-life, it might be helpful to digress for a moment in order to look at some of the ways of composing which can be used in a still-life painting.

These are literally endless, but, as I have remarked before, a strange limitation seems to come over many peoples' minds when they start composing a still life. A set of academic principles can all too easily descend like a screen in front of direct reactions to the subject. One of the ways of overcoming this is to be aware of as many different approaches as possible. At one stage this may lead to a rather over-conscious and deliberate approach, but as one goes on getting more experience of painting, one's attitude to these problems may well become more natural and instinctive.

Knowing something about the possibilities should, in fact, make a painter more free to react to what is in front of his eyes without preconceptions or inhibitions.

Fig. 27

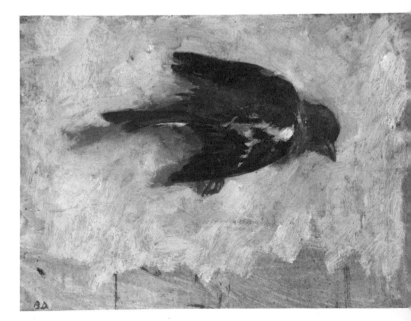

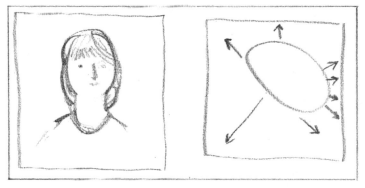

Fig. 28 Fig. 29

The simplest form of composition is that in which only one motif is enclosed or arranged within the rectangle of the picture. This may seem at first to be so elementary as to be hardly worth the title of composition; still, this sort of design is such a universal one that we ought to consider it first. Think of a portrait, for instance. If you are painting a head, without including hands or other elements, you are almost bound to use this one-thing-in-the-middle structure (Fig. 28). Any self-contained object which the painter has been interested in making a study of for its own sake, like the dead bird on the previous page (Fig. 27), will come into this category too. And this is certainly one of the motives for painting a still life that we should consider. It tends to get forgotten, in all our talk about composition and colour, that one of the most powerful reasons for painting at all is simply that the artist has been so taken with the look of something that he wants to copy it. As Constable said 'The clouds and the trees seem to ask me to make something like them.' The motive of 'making something like' is certainly not to be despised, and has little to do with 'mere mechanical copying', or any of those derogatory terms which get brought out in discussions about realism and naturalism. Anything done with love for the subject cannot, in fact, be a mere photographic copy. That's half the point of it.

When I found the little dead chaffinch in the garden, I was so charmed by its beautiful colour that the only thing to do seemed to be to try and paint it. There didn't seem any particular point, even, in making it into a picture. Simple transposition in terms of oil paint was sufficient motive to keep me at it until the light went. It turned out, in any case, to be extremely difficult.

41

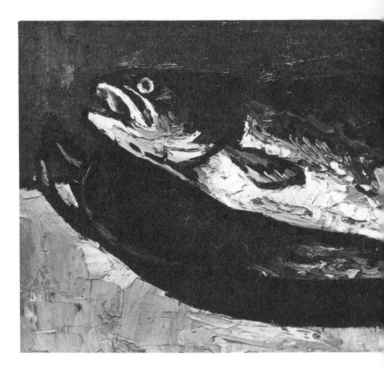

Fig. 30 *Fish* by Kyffin Williams

To return to our subject of composition: this resolved itself, in the painting of the bird, into placing a spot, or patch, within a rectangle. As soon as you do this (see Fig. 29 on the previous page), a relationship is set up between the spot and the limits of your rectangular picture-space. Tensions are set up, as shown by the arrows, between one and the other, and spaces are created which are as important as the solid forms themselves.

The same thing happens in the case of a long shape, like the

fish by Kyffin Williams reproduced here. Again there is only one motif; again, it has to be placed as a silhouette within the rectangle to make satisfactory shapes around it. In both these pictures the actual placing is fairly symmetrical, so that the object sits roughly in the middle. But notice that both the fish and the bird have what one could call a natural focus—the head—which is to one side. This works against the symmetry, by giving a fairly strong pull, psychologically, to one side.

Fig. 31

I am sure that Kyffin Williams's motive for painting this fish was exactly the same as mine in painting the dead bird—simply a strong desire to put down something of the extraordinary beauty of colour and shape which one finds in natural forms.

So much for the single motif. It can be a self-sufficient and extremely attractive theme for a painting, even if its complexity is all in the subject itself and hardly at all in the compositional form of the picture.

These two examples both used the minimum of surroundings —simply a flat table-top, and not much of that. As soon as the areas around are made larger and more important, and the main motif is made smaller in scale, as in the example shown here, we

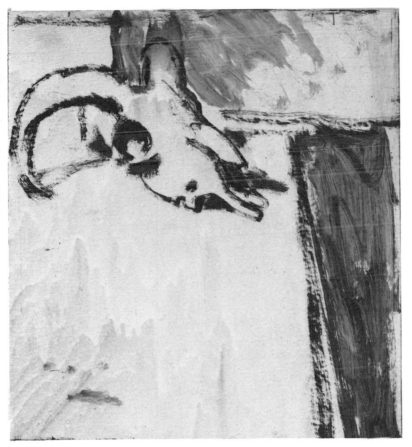

Fig. 32

are setting up a different kind of tension.

The subject is now as much the large opposing shapes of wall and table as the object itself, and we are composing with several large flat areas and one small, complex one.

This will happen to some extent even if we use only an exaggeratedly large area of, for instance, empty foreground. The drawing on this page shows how this huge blank space becomes in itself a powerful element in the design, so that one could hardly call this any longer a composition with only one motif; rather it deals with two—empty space and small intense shape— and they make a kind of equilibrium, rather like weighing a pound of feathers against a pound of lead.

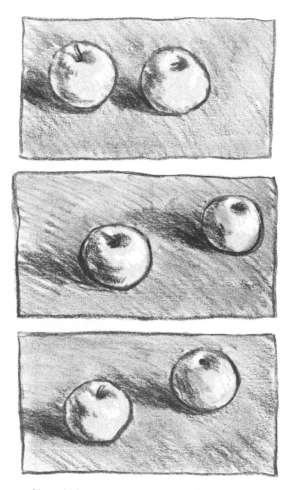

Fig. 33

Fig. 34

Fig. 35

Now let's see what happens if we take another element and put it into our picture, thus giving ourselves two to deal with. They can be two separate objects of the same or different characteristics, or they could be two separate groups.

To make the problem as simple as possible, let us take two apples on a plain table-top and explore some possibilities, always keeping in mind the idea of the rectangle of the picture framing the group and thus putting the whole thing into a pictorial framework.

Which arrangement seems to you the happiest out of these? Most people will probably settle for Fig. 34. Why is this?

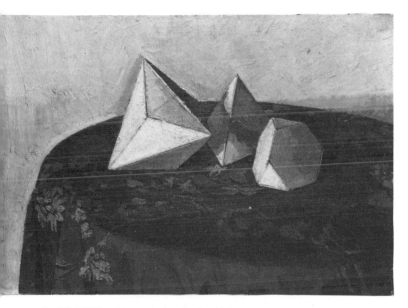

Fig. 36 *Still life with tetrahedron* by Patrick Symons

Simply, I think, because this arrangement has a certain amount of variety. The two apples are not exactly symmetrical and level, as in Fig. 33, and the gaps between them are not exactly equal, as in Fig. 35.

A warning here. I am inclined to think that all attempts at instruction in painting, and particularly in composition — especially if there is no one to answer back — should always be qualified by exceptions, to prevent their becoming too dogmatic. One should be continually pointing to pictures which work in quite a different way. The small painting by Patrick Symons on this page is very carefully designed, but the design has sprung, as I think all designs should, from the painter's interest and involvement in his subject — in this case, related mathematical forms. They are pushed together on the tablecloth, in rather the same way that Morandi (Fig. 47 p. 54) groups his objects closely, and show that it is not always necessary to spread things out in order to fill a space satisfactorily.

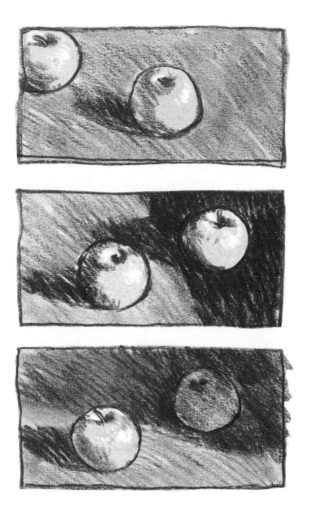

Fig. 37

Fig. 38

Fig. 39

To return now to our design using two apples as separate units. We can take this a step further and alter the respective emphasis of the two apples by various means. One of them can be partly chopped off by the edge of the picture (Fig. 37), or the tonal relations can be changed. Up to now we have been considering our two apples as equal, tonally; but obviously if we put one of them against a darker patch of background (Fig. 38) or into an area of cast shadow (Fig. 39), we are altering the whole emphasis of the design.

48

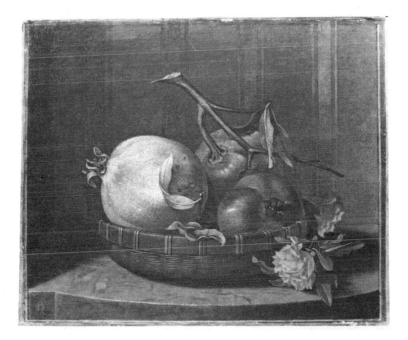

Fig. 40 *Pomegranates* by Maxwell Armfield

The last two examples show how similar forms can be varied by the use of counterchange. This simply means the contrast between light against dark, and dark against light. It has always been used in composition, and the Venetians and the Baroque schools were masters of its use. However it is not an artificial device; it is remarkable how continually it occurs in nature, where a dark area against light turns, almost as if with intention, into a light shape silhouetted on a dark background.

A simple instance in landscape is the light tree-trunk which becomes dark against the sky. But anywhere you look, you will probably be able to find examples of this natural variation in the quality of a silhouette.

The small painting reproduced above does not use counter-change quite in this sense, but shows a very subtle contrast between light shapes—such as the large fruit on the left and the small leaves on the right—silhouetted against dark shadows, and the other more unassertive edges.

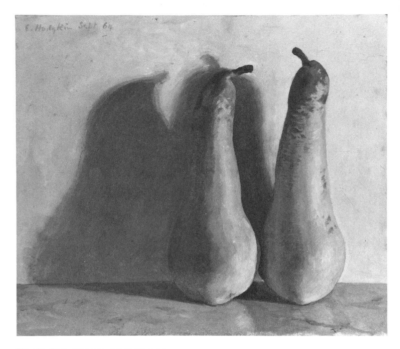

Fig. 41 *Two Pears* by Eliot Hodgkin

This picture by Eliot Hodgkin shows a very elegant solution to the problem of composing two equal elements together. The cast shadow is used with great skill to introduce what amounts to a third shape, similar to the shapes of the pears and echoing them, but subtly different in silhouette. The two pears are placed with complete simplicity, side by side, and the result is far more interesting than would be a conscious attempt to vary them—by tilting, or putting one on its side.

Notice one very important point about this picture, the variety and subtlety of the edges. As the eye moves across the shapes, it meets a continual change in the character and emphasis of the silhouette, from light against dark to dark against light, from soft to sharp.

The small painting of a quince and lemon reproduced in colour here (Fig. 43) is another attempt to relate two equal forms.

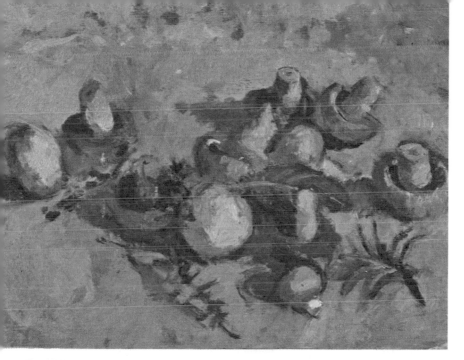

Fig. 42 Mushrooms

Fig. 43 Lemon and Quince

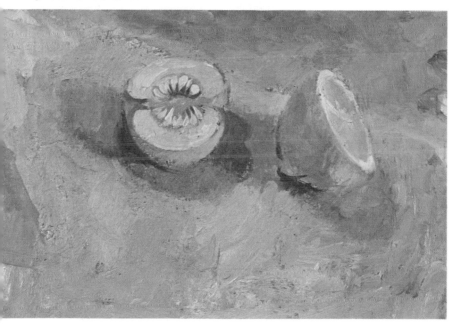

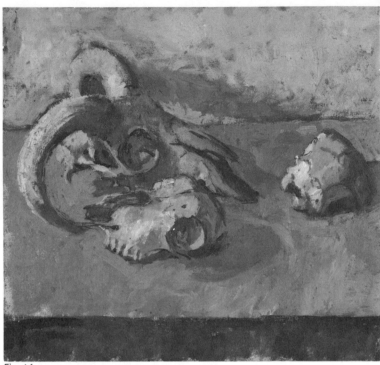

Fig. 44

Now add another to our two motifs, and the whole problem becomes much easier. It is always simpler to compose with three than two, for there is no longer the tendency to fall apart into two equal halves. Instead, we are likely to end up with one large group and a smaller, balancing one.

This is a classical and traditional type of design, and can be found in all shapes and sizes in the Old Masters.

We have already dealt with the frieze-like character of a row or line of objects, and it is unnecessary to go into this in any detail here. However, we could make a distinction between the row of undifferentiated shapes, all of which are roughly the same size, such as can be seen in the painting of gourds on p. 53 (Fig. 45), and the sort in which the row is punctuated by one or more larger shapes, of which the drawing of a painting by Braque on the same page (Fig. 46) may serve as an example. Along the long thin shape of such a picture, the succession of forms, read as they naturally are from left to right, make an effect which can be compared to a musical phrase, rising to a high note and falling again.

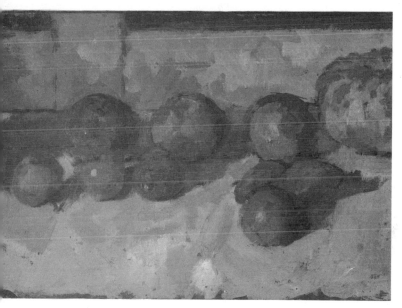

Fig. 45 Gourds

Braque was a master of the long thin format, which he used over and over again with great resourcefulness. In a shape like this, which is about two-and-a-half times as long as it is high, the divisions and accents across the length become very important because of this tendency to read across; whereas a squarer shape is more self-enclosed, more dependent on what is happening at the centre and in the corners.

Fig. 46

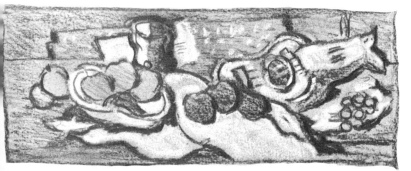

Fig. 47 Still life by Morandi

This leads us to the commonest of all still-life arrangements—
that in which one shape, often a jug or other container, dominates
the rest of the group by its height. Sometimes, as in the Chardin
I have made a drawing of opposite, it is a round object which
dominates. The unfinished Cézanne on p. 24 (Fig. 16) is put
together like this; and another good example is the picture by
Morandi on this page. Morandi is a very fine Italian painter, who
is known almost entirely for his still lifes. He is a master of the
use of apparently commonplace arrangements of deceptive
simplicity. Over and over again he has painted groups like this
one, which makes me want to take back everything I have said
earlier about the 'art school still life'; they are often grey and
muted in colour, and one could imagine them standing in a dark
corner, with a notice saying 'Please do not touch' propped up.

Nonetheless these modest pictures have a remarkable air of authority. Their air of stillness is enhanced by a very unpretentious and quiet handling of paint. This one adds to its calmness by an almost complete symmetry in the placing of the central bottle. In front of it are three bowls in a line; the regularity is only broken by the jar on the left at the back, and even this is exactly by the side of the bottle and corresponds to it in width. All the objects have the same cool tonality. The colour throughout the picture is based on grey, brown and white.

This is an example of how the simplest and most puritanical means can be made deeply impressive by the artist's sheer intensity of belief in what he is doing.

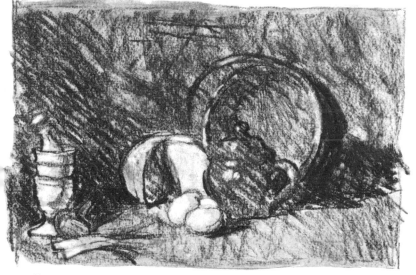

Fig. 48

Chardin and Morandi inhabit the same world of calmness and still material substance. The design of this painting by Chardin is far more complex, as the quality of the paint is much more earthy and varied. It depends, too, more on tonal variety. Everything is off-centre here, and though the pan is the largest object, the focus of the design takes place to the left of it, where the strong light falls on the sharp angle of the bread.

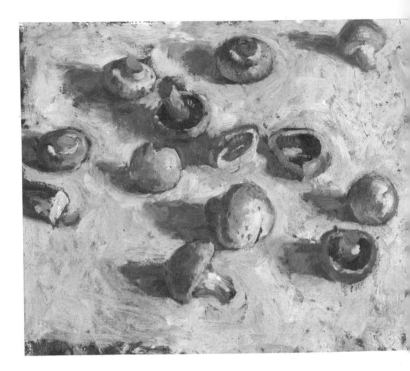

Fig. 49

Finally, in this very superficial glance at some of the ways in which a still-life painting can be organised, we should mention a way of filling the picture surface by creating an 'all-over' pattern. In this type of organisation, no one element is dominant; the forms are scattered, and the charm of the picture depends very much on the vivacity and liveliness of the small shapes. This sort of picture could well be developed from a number of small units, like the painting of mushrooms on this page. This picture comes under the heading of 'unarranged' still life, as its design was fortuitously arrived at, simply by emptying a bag, and I will be referring to it again later.

Notice how, quite by chance in this case, the angles of the mushroom stalks create opposing directions. There is plenty of variety in the shapes, and in the change of tone caused by the varying angles of the mushrooms. All this variety helps to give energy to the all-over pattern, and prevents it from becoming monotonous.

Fig. 50 Still life by Euan Uglow

I would like to enlarge a little on two other aspects of design which have already been mentioned briefly: symmetry, and the use of empty spaces. Both tend to be avoided by amateur painters. They are afraid, on the one hand, of their picture 'falling into two halves' because of a too symmetrical arrangement; and, on the other, of dullness or emptiness resulting from the use of flat areas. Neither of these fears is necessarily justified. They are often the result of some dogmatic statement by a teacher, often dating back to schooldays. It is always worth re-examining these prohibitions, (another well-known one is that one 'shouldn't use black'), to find out how much truth they really contain for you.

Symmetry, for example. Is there any real reason, when one comes to think of it, why a picture shouldn't be considered as two halves which add up to one whole? If you walk round a gallery you may well be able to find a number of paintings by Old Masters which do just this, and bring it off. And there are certainly many successful formal compositions in which the main subject is placed plumb in the middle, and is supported by equally balanced figures at the sides; for example many paintings of the Madonna and Child with saints or angels by Italian masters, such as Mantegna, are designed in this centralised way.

One could say that any means may be used successfully as long as they are intentional. Thus if you put an important part of your picture right in the middle, it should look as if you meant it to be there, as Morandi clearly intended his bottle to be (Fig. 47 p. 54).

Here is a painting by Euan Uglow in which the possibilities of exact symmetry are explored (Fig. 50).

Fig. 51 *Pot à Tabac, fond bleu* by Henri Hayden

The same thing applies to the use of empty spaces and flat areas. Many amateurs feel instinctively that every part of their painting must be 'made interesting', and of course this is perfectly true; where they often make a mistake is in thinking that this means that something must be going on in each area—some gradation of colour or change of tone, if nothing else. It is quite difficult for a beginner to put down a flat, unworried area of paint without immediately beginning to stir it up.

Yet flat paint can be extremely beautiful. It can create areas of rest and serenity in opposition to other more complex smaller forms. And in any case, however empty the area is, it is still colour. Think of the beauty of the flat paint in a Matisse, for example—great coloured open spaces, in which the colour can speak undisturbed by tonal changes, obvious brushwork, or anything else.

Here is a painting by Henri Hayden in which an almost unmodulated ground of beautiful and tender colour is used. The three objects are placed on this flat surface with deceptive simplicity and are observed with a certain relaxed gaiety; Hayden was eighty-five when he painted this small gouache.

6 The unarranged or accidental still life

After this digression about design, we can come back to the specific business of finding our subjects. We have discussed the formal arrangement of still life; now let us turn to a process which can better be described as selection—choosing from the wealth of ready-made subjects all around us.

There are still lifes wherever we look. We spend our time, in fact, surrounded by possible subjects, waiting to be noticed and perhaps painted. These still lifes may last only a few minutes— even a few seconds—before they change in the flux of everyday life. A draining board by a kitchen sink will, like the stage of a theatre, contain a series of such momentary arrangements in the course of a day.

Most people see only what they are looking for. Their vision is attuned to the demands that their occupation makes on them. Only the painter really uses his eyes, and sees things for what they are, and not merely what they stand for. Even the painter has to develop this 'hungry eye' gradually, and may still see, so to speak, in compartments.

One of the best ways of training the painter's eye is to get into the habit, at odd moments during the day, of letting the eye wander about and rest on the accumulation of facts which are always waiting to be confronted. If you have a notebook handy, so much the better; you can put down, in very simple terms, a note of anything that strikes you; but the habit of seeing can be inculcated even in a busy train on the way to work, or over lunch. Get into the habit of looking and analysing what you are looking at; mentally 'framing' a fragment, to isolate it and put it into a pictorial context.

You can go further than this; you can make whole series of tiny drawings of such commonplace sights as your dressing-table, your breakfast, your clothes thrown over a chair. If you were able to do three or four notes like this every day, you would soon fill a notebook, and more important, by doing so you would have gone some distance towards training your capacity for seeing and choosing.

Fig. 52 p. 60 is a superb example, by the Scottish painter William Gillies, of what I mean by the unarranged still life. This is the kind of jumble of objects that could be found in any studio or inhabited room.

The painting by Gillies is quite a large and elaborate design, and I don't know how much the things were moved around before he started to paint, if at all. I should imagine not very much; it has the look of something 'found' rather than 'arranged'.

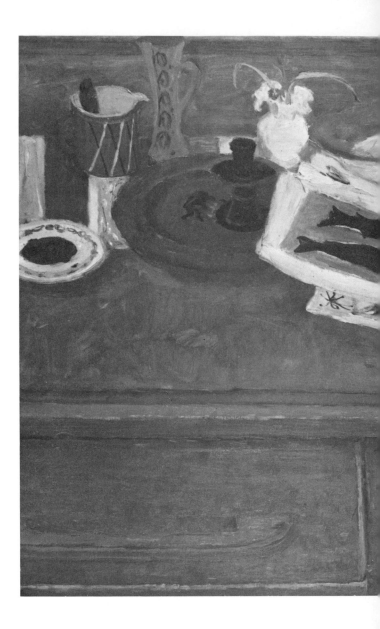

Fig. 52 *Still life, black fishes* by William Gillies

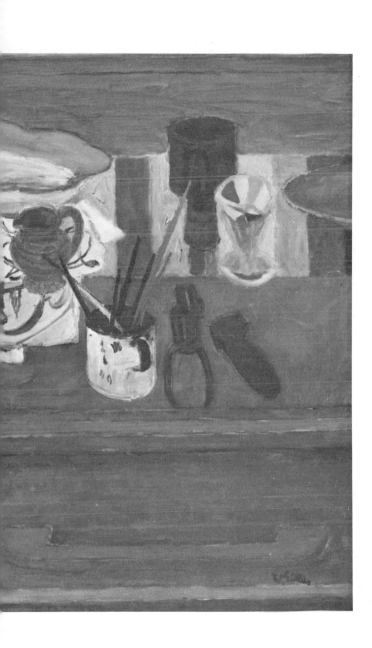

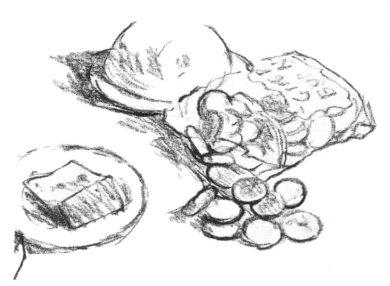

Fig. 53

Fig. 54

Here are a series of drawings made in various rooms around the house, exactly as they happened to catch my eye. All I have done is to choose them and to decide on the format they were to occupy.

I should add that I make no claim whatever for these scribbles as drawings. They are simply the sort of thing that I would recommend for quick notes at odd moments.

I think one of the most important things one learns from this process is that anything will do to paint from. There is no sense in categorising things as paintable or not; and it is not even

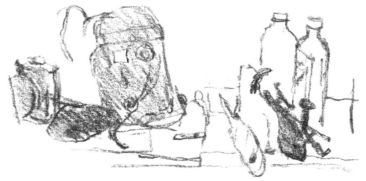

Fig. 55

Fig. 56

particularly necessary to know what they are, or to make them identifiable.

Thus the shelf of objects above contains several shapes that are difficult to name, and which would probably not find their way into an arranged still life, because they might not 'look right'. And the bag of ginger biscuits in the drawing printed on the opposite page is not, perhaps, the first thing that would come into one's mind when casting about for subject matter. I found when making this note that it was unexpectedly fascinating to draw. The variety of shapes made by the jumble of identical discs,

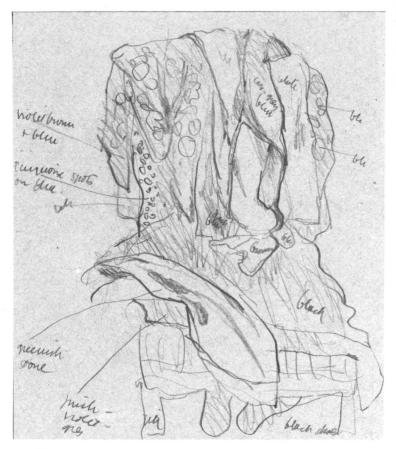

Fig. 57

and the shapes of them seen through the transparent bag, made me feel that there are possibilities in this sort of 'supermarket' subject matter which might be explored.

In this way, an accidental find may give one the germ of an idea for a more considered picture. Another point about this kind of subject is that there is often the additional incentive of dealing with something that one has never seen a painting of before. There are probably far more 'untouched' subjects about than one might think.

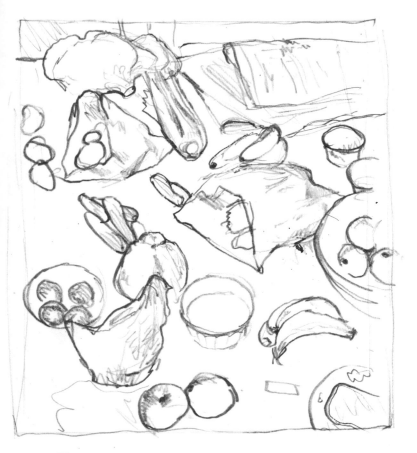

Fig. 58

The drawing on the previous page (Fig. 57), of clothes thrown over a chair, is another example of a familiar subject that has not been exploited overmuch. This particular study was done for a painting, hence the colour notes written on it (see p. 87).

The composition of an accidental group resolves itself into two acts of choice—deciding on one's viewpoint, and selecting how much to paint. Exactly the same thing, of course, applies to composing a landscape.

This crowded table-top can be compared to a landscape; but one which can be surveyed freely from any angle, as if from a helicopter. It contains enough material for a number of distinct and separate compositions.

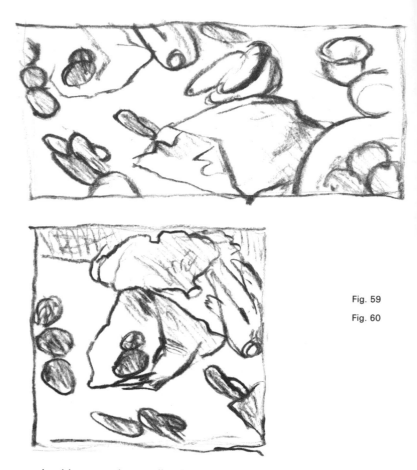

Fig. 59

Fig. 60

In this case, the small selected compositions were arrived at
without any alteration of the angle of vision. The procedure here,
indeed, is rather like that of a photographer enlarging a small
portion of his negative. This selection, or cutting, is a very im-
portant aspect of the painter's vision. To do some studies along
these lines is to become more aware of the way one can arrive
at several totally different results from the same subject.

When selecting from a mass of material like this, one is almost
bound to 'cut' the shapes so that only parts of some objects are
shown. Some beginners are nervous of doing this, and prefer to
arrange a group so that every part of it is well within the confines
of the canvas. This may be due to a fear that bits of objects won't
'read', i.e. they won't make sense. But, when you come to think

Fig. 61

Fig. 62

about it, a landscape painter, or one who is composing an interior, is bound to be cutting like this all the time. And objects cut by the side of the picture are very valuable in the way that they create new and unexpected shapes in relation to the edges.

You may find it easier to select small areas if you 'frame' them roughly with the fingers or the hand, as in the drawing above.

On the next two pages are reproductions of successive stages in the painting of a group that 'just happened' in the way that we have been discussing. The subject is a perfectly ordinary one, such as could be found in any kitchen, and I have painted it exactly as it happened to occur. It is a typical example of the way that objects in everyday use seem to arrange themselves in natural ways, which could hardly be improved by conscious re-arrangement.

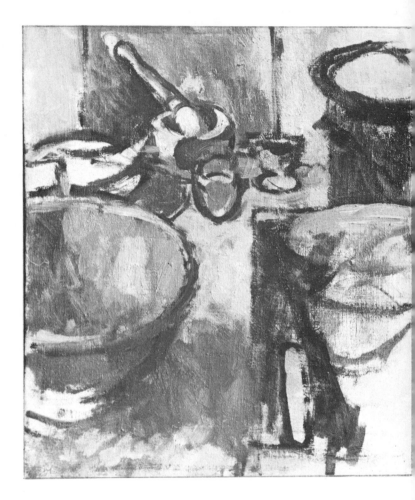

Fig. 63

My eye was first attracted to this group by its charm of colour, and then by the way the shapes divided themselves into large areas and smaller, more complex ones. I find that for me this is a very usual response, and the way that most subjects present themselves. Colour tends to come first, and then shape. There has got to be a combination of the two to spark off, like a chemical reaction, the desire to paint. And of course the other essential is a sympathy for the character of the subject. All these requisites

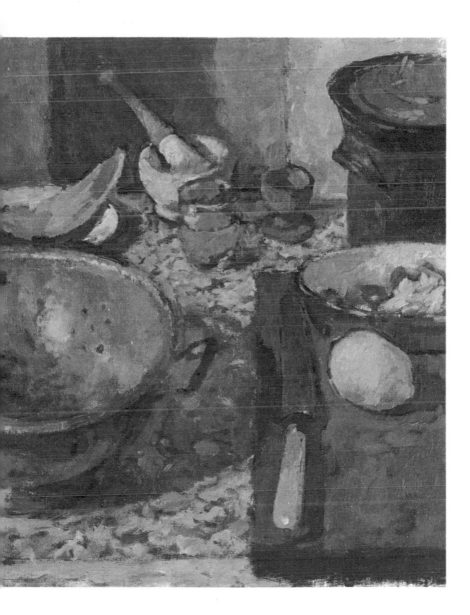

Fig. 64 Kitchen Table

were satisfied here, and the next stage was to make two important preliminary decisions. First, the viewpoint; and second, how much material to include and where to cut it. Taken together, these decisions should lead directly to a choice of format for the picture—whether it is to be square, vertical or horizontal in shape.

Fig. 65 Fig. 66

The choice of viewpoint was an easy one. I have an instinctive liking for designs based on serene horizontal and vertical lines, rather than on diagonal directions; and in the case of a table-top like this, it seemed natural to look at it directly from the front or the side. I think it is often very difficult to compose a group if the front and back of the table create very strong diagonals; they seem to dominate the design and produce a restless effect, as can be seen in the diagrams here.

As seen from the front, the table-top was divided vertically by the line of the bread-board. This also made a strong tonal division from light to dark, and the vertical emphasis was continued towards the top of the picture by the brown jar.

I thought of the design in terms of the large shapes of the brown bread-board and the grey colander, at the bottom, leading

upwards to the climax of the row of small, rather intricate, silhouettes at the top. I was interested in the way that the pestle in the mortar, and the slice of melon, met at an oblique right-angle, making a sharp accent; the 'framing' of these elements by the rectangle of the canvas followed from the need to make the small shapes at the top sufficiently prominent in scale. Any description of the painting of a picture is bound to sound much more conscious and logical than the actual process can ever be. The design of this picture was not, in fact, worked out in great detail beforehand. The decisions I have described above were to some extent carried out on the canvas itself, and were even dictated by the particular canvas that I wanted to use.

This was a fairly small one, about 12" × 14", as I wanted to do the painting quickly. I like to carry out a still life in as short a time as possible, to retain the freshness of the first impression; and in any case speed is essential if the subject is discovered in a room, like a kitchen, which is in constant use. In this case I was able to start one afternoon and finish the next morning, after warning the household—ineffectually, as it turned out—that nothing was to be moved!

I worked very close up to the group. In fact I was sitting on a chair with a paintbox on my knees, and the top of the canvas—supported by the lid of the box—was only a few inches away from the front of the table. This has the advantage of bringing one into very close contact with one's subject; but it may also have the effect of exaggerating the perspective. One is looking slightly downwards at the nearest objects. But personally I don't mind this slight 'stretching' of the foreground, and I like the feeling that I can reach out a hand and touch the things I am painting.

The canvas, though primed with white lead, bore the traces of a previous painting—a failure that had been wiped out, leaving an irregular ochre smear. It may be no disadvantage to use an old canvas, provided that the paint on it is reasonably thin and not too intense in colour; the need to cover up an already marked surface can make one work with greater decision and vigour.

It is difficult to write about the actual painting of a picture, because one's actions are not necessarily very logical—the thing does not unfold in neat stages, and, if it did, it might well become boring. Every painter has a different response to an empty canvas, and in fact every painting has its own tempo, its own false trails and setbacks; so all I can do here is to give a very personal description of what happened in this one case, without trying to make any logical course of action or set of rules out of it.

The first act was to establish the bigger areas and divisions roughly on the canvas, using a brush and some rather neutral colour. Then some of the larger areas of tone—the brown bread-board, the warmer brown jar, and the grey colander—were rubbed in with thin paint, getting them as close to their actual colour as possible. Beginners will sometimes say, in reply to a criticism of some unsatisfactory piece of colour, 'Oh well, I just put that in for the time being, I'm going to alter it.' I don't see any point in placing a colour on the canvas unless it is as close as one can get at the time to the actual colour one wants. It seems pointless to put down a colour that isn't right, and doesn't even try very hard to be right, only to cover it up again. So each successive touch of colour on the canvas was an attempt to get a little nearer to the desired relationship.

Fig. 67

It may be of some interest at this stage to mention the actual range of colours that I used, and this can best be done by making a sketch of the arrangement of the palette.

There are one or two points I would like to make about these colours. The palette was not specially set for this picture; the

drawing shows the normal range of colours that I keep on the palette. I was using them, during the period in which I was doing this still life, for two other pictures, very different in character—a large figure painting, and a very small interior. I might actually use no more than four or five of these colours in any one sitting, but I still like to have them all ready.

Some beginners are inclined to think that one range must inevitably be better than another, and they get thoroughly confused with the very different advice they get given. All I can say is that this palette suits me—for the time being—but may not suit you. You must experiment. You may prefer to use fewer colours—I don't think you are likely to need more—but even then, remember that there is no particular virtue in using a restricted range. If you find yourself in difficulties because of the lack of a certain colour, go out and buy it.

This is not to deny the value, for a special purpose, of sometimes selecting a narrow range from your complete one, and seeing how far it can be made to go. Later on I will suggest one or two exercises using a limited range.

To return to the particular still-life painting; I don't intend to try to describe in detail how it developed, as the actual process of painting was kept as direct and simple as possible. But certain things that did happen to it may be worth taking up here in some detail.

The first thing you will notice if you compare the early stage on p. 68 (Fig. 63) with the finished picture on p. 69 (Fig. 64), is that certain changes have occurred in the actual group and the way it is illuminated. This is almost bound to happen if you are painting in a corner of an ordinary room and cannot finish in one sitting, whereas a group set up in your studio can be kept in a relatively unchanging condition for quite a long time.

In this case one or two items got moved slightly, and the lettuce in the colander didn't look very attractive after being left there overnight; a lemon made its appearance, quite fortuitously; and the weather became dark and rainy. This last alteration made a real difference to the picture, because it meant that I had to turn on the light to see anything at all.

I could, no doubt, have waited until the weather improved, but one cannot always be waiting and putting off work because of the light; very little would get done at all at certain times of the year. Similarly, I could have reconstructed the group until it was exactly as it had been when I first saw it. But I am inclined to think that accidental changes are often changes for the better, or

at any rate can be turned to advantage. In this case the lemon was obviously a useful addition. The pure yellow gave a certain pungency to the colour and made an attractive relationship with the brown board, and the angle made by its axis struck me as connecting up usefully with other diagonal directions.

This was the main compositional change, though other slight adjustments had to be made. The alteration in lighting was at least equally important, and entailed a certain amount of re-working all over the canvas. This is no hardship to me—rather the reverse, as it forces me to go on painting constructively rather than merely filling up already established shapes. Re-painting should always mean re-thinking. Filling in without thought is always the danger when continuing with a painting, especially one of a static and undemanding subject like still life. Many paintings are only really alive during the first stages. Having to make alterations does, at least, prevent the whole thing from going to sleep.

After painting for a long time in London, often in ordinary rooms, I am now quite indifferent to the light I use. Provided there is enough to see by, it can be daylight, ordinary electric light, or the more powerful artificial light of my studio. If one intends to get a regular amount of work done, it is essential to come to terms with this problem. Artificial light is at least steady and unchanging, and it can have a beauty of its own. The clarity of the cast shadows can be used as an important element in a design. The one thing you will have to be careful about is the slight alteration of certain colours when seen in the warm light of ordinary electric bulbs—yellows need care.

In the studio I use a combination of a fluorescent tube with two ordinary 150-watt bulbs. This gives a very well-balanced colour, and I often start work in daylight and continue later with the lights on, without being aware of any difference.

The finished painting is not very satisfactory to me; it is a little too literal—not enough has been made of the subject. But I include it here because I think the point about making alterations freely, and seizing on possible improvements, is a valid one. When I say that the picture is too literal, I do not necessarily mean that the subject should be transformed or abstracted. Appearances can be respected, and yet modified and adjusted in count-less subtle ways. Rhythms are brought out, connections are seen and stressed, in a way comparable to a pianist's phrasing of a passage with the slightest changes of tempo, loudness and softness.

7 Still life as part of a composition

As well as being a subject in its own right, still life has always been used as an adjunct to other subjects. Some of the most beautiful examples of still-life painting occur in the corners, the foregrounds or backgrounds, of figure paintings. If they are isolated by photographing a detail, they can be seen as complete little pictures on their own. The Velazquez of fish and eggs on p. 10 (Fig. 2) is a supreme example of this. Here, the still life and the figures form equally important elements in the composition, as can be seen in this sketch of the whole picture.

Fig. 68

Bonnard's *The Table*, on p. 15 (Fig. 5), can more accurately be called a still life with a subsidiary figure. There is a fine early Matisse, *The Dinner Table*, which has a very similar relationship of a figure at the top bending over a crowded table.

A still life can often be used as part of a portrait, to make a reference to the occupation of the sitter. The portrait of Sir Frederick Gowland Hopkins, on page 76 (Fig. 69), had to be worked out very carefully from this point of view. All the apparatus shown is connected with his work, and some care had to be taken to get the detail right; for the portrait is a posthumous one, done from documents of the period (about 1930), and

Fig. 69 Portrait of Sir Frederick Gowland Hopkins F.R.S.

many of the details of laboratory apparatus, and even the type of bottles used, have changed considerably since then. Drawings were made in the actual laboratory, with the apparatus set up, and the general design was worked out from them. I then set up a similar arrangement in the studio, using borrowed equipment. Scientific subject matter presents certain problems. The hard glassiness of the surfaces can easily be overdone, and they can

look unpleasantly shiny and out of character with the painting of the figure.

The long burette (glass tube) on the extreme left, with its thin straight shape, was particularly tricky, for the highlight cannot be placed mechanically with a ruler, or it looks too harsh; and in the actual piece of glassware it changes continually in sharpness and in brightness down the length of the form.

I find it quite stimulating to tackle a subject like this, in which documentary truth of detail is important. Even the colour of the solution in the test-tube was made as accurate as possible.

If you turn back to the title page you will find a detail from Holbein's *The Ambassadors* — a still life of scientific instruments which, to me, is the most beautiful statement ever made in paint about this field of subject matter. Here, of course, the figures and the still life are painted in exactly the same very precise idiom and are related without difficulty. There are two still lifes in *The Ambassadors* and they sum up the culture of the period.

On the next two pages (Fig. 70) is a painting by Louis Finson, a Flemish artist of the early seventeenth century, which is a particular favourite of mine. It combines a figure with an extremely complicated and magnificent still life, to make a total effect which is full of strange qualities.

The still life itself is one of those uninhibitedly crowded and lavish affairs which the Flemish painters loved for the chance they gave to show off their mastery of form and texture. Fruit, jugs, gourds, musical instruments, are heaped and scattered about with magnificent appetite. There are even two separate still-life groups on the shelves which would be quite enough in themselves to make complete pictures. And the painting abounds with curious touches, such as the gourd which hangs by a string from the shelf — the sort of oddity which, as I said before, one is more likely to find in a painting by an Old Master than in a modern work, which usually contains comparatively conventional material.

One point worth noticing about this picture is the way that diagonals have been used in the design. The main diagonal of the recorder, in the middle of the picture, is echoed by the violin on the right, the shadow under the shelf, the shadow across the man's cheek; and these oblique directions are countered, almost exactly at right angles, by the tilt of the hat and the cast shadow running across the jug on the left. The way that lines within the picture can play against one another like this can be very useful in holding a complex design together.

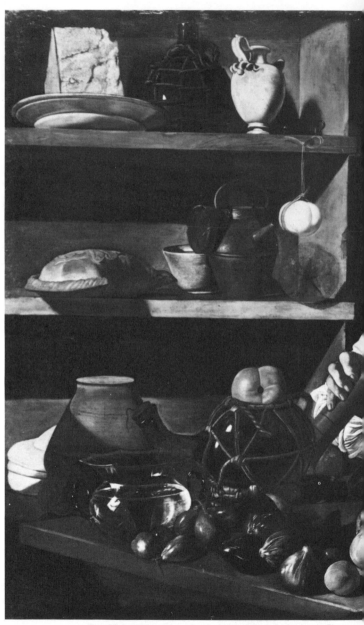

Fig. 70 *Interior with a man holding a recorder* by Louis Finson

8 Flowers

Flower painting is such a popular and important branch of still life that it merits a chapter to itself. It is also a *genre* which appears to have suffered a distinct lowering of standards in this century—to such an extent, indeed, that the very term Flower Painting suggests an insipid and mediocre type of art to many people.

There is absolutely no reason why this should be so. Flowers can still be painted with decision and conviction, just as any other subject can. But it is certainly true that one does not see very many good flower paintings in contemporary exhibitions. Perhaps this is due to the distrust shown by many modern painters for a subject that is essentially charming and delicate in itself. For that matter, how many first-rate modern painters working in a figurative idiom are prepared to deal with the equally 'obvious' subject of portraits of children?

Yet if one thinks of paintings by Vuillard, Bonnard, Suzanne Valadon, Matthew Smith, it is clear that this traditional subject can still be tackled in a meaningful way, as long as it is approached (and this, of course, goes for any subject) without preconceptions or prejudices.

Very loosely, one could say that there are two main ways to approach a flower painting. The first is dependent on extremely precise drawing, which parallels in its delicacy the character of the plant. The other is a more painterly approach, which uses the richness and weight of oil painting to say something about the luxury of colour we find in flowers, without attempting an exact delineation of their shape.

The first method is not, perhaps, suited to oil paint. The example (Fig. 71) I have chosen to illustrate it is, in fact, a tempera painting. Tempera, like the other water media (gouache and watercolour), is capable of very delicate drawing, and is thus particularly well suited to this subject. But it has its own difficulties. Its tempo is essentially a slow one. The picture needs to be planned in advance—for the medium doesn't lend itself to second thoughts and changes of intention—and built up gradually from notes and drawings, rather than painted directly from the subject.

The painting by Maxwell Armfield could have been done in oil, but it would have developed a different, more laborious quality. It is very difficult, even with liquid paint and a sable brush, to deal with such passages as the serrated edge of the leaves in the medium of oil paint. You can see how heavy and laborious an effect can result in some modern oil paintings which

Fig. 71 *The Compotier* by Maxwell Armfield

Fig. 72 *Vase of Flowers* by Monet

mistakenly attempt a 'Dutch' quality. Our modern tube colours have quite different characteristics.

Tempera, on the other hand, has a clarity and a lucid beauty of smooth surface which is ideal. I would recommend anyone who likes working deliberately to try it, using the traditional technique of powder colour mixed with water and egg-yolk as a medium, on a smooth gesso ground.

Oil paint does seem to demand a broader and fuller way of working, in which one seeks equivalents for the character of the subject in ways other than by crisp delineation.

The *Vase of Flowers* by Monet, reproduced here (Fig. 72), is a good example of this vigorous attack, and one which could be said to represent the extreme opposite to a linear idiom. The flowers are translated entirely into terms of freely-handled oil paint and no attempt has been made to define an exact shape, apart from the big silhouette. The mass of leaves is translated into a network of hatching strokes, and the flowers themselves into broader dabs and touches. There is a remarkable grasp of the mass and weight, the sheer physical impact, of the subject.

As might be expected, the colour changes are extremely rich and subtle; there is a delicate precision and control in the context of this broad handling. In the hands of other artists who lack this subtlety, breadth and vigour can easily degenerate into mere coarseness, and it would be pointless to try to work as freely as this without a great deal of experience.

I have often felt myself that one of the main difficulties in painting flowers is simply that the forms and colours are so delicate that one's painting looks discouragingly clumsy beside them. In fact it is often only when the flowers have died and been thrown away, so that there is no direct comparison, that the qualities of the painting can be seen.

Whatever idiom you use—I would prefer to say whatever tempo you paint at—try to attain in your painting some of the vigour of shape that all plant growth displays. However fragile a bloom or a leaf may seem, it has tremendous strength in relation to its mass. If you have ever seen one of those slow-motion films of a plant growing, you will appreciate the powerful thrust and energy with which such apparently delicate structures grow and are held in place.

It is an excellent discipline to make some drawings of plant forms, using as direct and simple a method as in the ones shown here. Choose any plant which has reasonably big and comprehensible forms. Pay particular attention to the negative shapes—

Fig. 73 Detail of drawing by Diana Armfield

the gaps between leaves and stems, for example. They are as full of character and as important as the forms themselves. This can be seen clearly in the drawing above.

None of the curves in a living leaf-outline are limp or mechanical; they have a quality of springiness, a vigour of curvature about them. This is well illustrated in this Japanese drawing, done with the brush.

The beautiful drawing of sunflowers by Charles Mahoney reproduced opposite (Fig. 75) has all these qualities; it also shows that a study of plants can have a strong and decorative quality on the page.

Fig. 74

Fig. 75 Sunflowers by Charles Mahoney

9 Still life as a way of finding out about painting

Still life has always been used as one of the most convenient ways of studying painting in art schools. In the old days, students would paint a still life as a sort of intermediate stage between drawing and painting-from-life. In present-day teaching, this is interpreted much more widely; still life is used as a basis for all sorts of exercises and projects, ranging from the purely objective to the abstract.

This chapter will be concerned with suggesting ways in which the amateur can use still life in this wider context—not only to gain practice in the observation and representation of forms and relationships, but also in the exploration of some different aspects of picture-making and the use of paint.

The way this is done in many art schools nowadays may be summed up as follows. The student used to be confronted with a fairly complex subject—a group of objects, a head or a figure—and would be expected to jump in at the deep end, so to speak. In struggling to make something out of the diversity and intricacy of his subject he would gradually begin to find himself as a painter. This could be compared to a young pianist confronted with a Mozart sonata. It would seem more reasonable for the beginner to tackle simplified problems, subjects in which one or another aspect of drawing or painting has been isolated, just as the pianist starts with exercises designed to increase his powers by concentrating on one or another technical difficulty.

This concept can be taken too far, until it becomes just one more academic theory; and I don't want to get too didactic about it. Learning to paint is not altogether comparable with learning other techniques; it certainly cannot be divided up too much into a neat succession of stages from easy to difficult. It is possible, in fact, for students to go through a whole course of projects, carefully planned by experienced teachers, and to come out at the end still as incapable as ever of painting an actual picture which carries any conviction at all. There is, to my mind, still a good deal to be said for learning to paint by trying to paint 'real pictures'—and probably making a mess of them.

Still, the idea of using simplified exercises can be useful, as long as it is used sensibly, and not only to the beginner, either. I think that every amateur painter could usefully extend his sensibility to certain aspects of his craft, even if he has painted for some considerable time, by trying some of these simplified problems, and perhaps evolving others for himself.

Here, then, are a few projects that you might find fruitful if you feel that your ideas about painting are in a rut and need a new

stimulus. They have all been tried out in the actual course of teaching.

Colour

So far I haven't talked about colour a great deal. This is because I believe that theoretical knowledge about colour is generally of little use to the painter. More than in any other field, the education of the painter's eye for colour is an empirical, and often very gradual, process. He begins to develop a colour sense, (unless he is one of those few and exceptional people who are lucky enough to have a natural sensibility for colour), by a long process of painting pictures some of them almost monochromatic — looking at colour relationships and trying to analyse them, and looking at other pictures of all sorts.

So we are not going to consider colour theory here, or bother about colour circles, complementaries or primaries. We will stick as far as possible to practical approaches.

First, here is an exercise concerned with the analysis of observed colour. It is possible to sharpen one's powers of observation without even mixing any paint on the palette, by making written notes. Take any simple arrangement of objects, and, on the basis of a linear drawing, try to write down as accurately as you can a description of each area of colour.

A drawing of this sort is shown over the page (Fig. 79). There are one or two points I should mention about the way it was done. The tone, or value, of a colour cannot be separated from its other characteristics. We need to be able to annotate not only its hue (its redness, or greenness) and its intensity (how strong or how weak it is), but also its darkness or lightness. For this purpose we can use a code of numbers. Each degree of darkness in a tone-scale from dark to light can be numbered (Fig. 76).

Anything that you look at can be considered as if it were a series of patches of colour side by side on a flat surface; and each one can be analysed in this way, not forgetting the areas of background surrounding the objects themselves. Thus, looking at a

Fig. 76

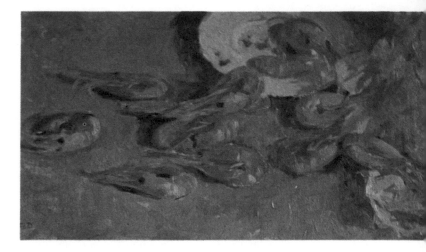

Fig. 77 Prawns

Fig. 78 Study of colour
changes on a flower

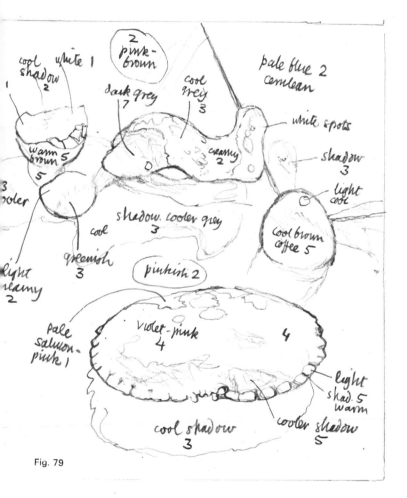

cool white 1
shadow 2

2 pink-brown

cool grey 3

dark grey 7

pale blue 2 cerulean

white spots

creamy 2

shadow 3

light cool

warm brown 5

5

3 cooler

shadow. cooler grey 3

cool greenish 3

cool brown coffee 5

pinkish 2

light creamy 2

pale salmon-pink 1

violet-pink 4

4

cool shadow 3

light shad. 5 warm

cooler shadow 5

Fig. 79

red patch, one can analyse it in this way: this is a crimson-red, rather dark—about No. 5 on the tone scale—and strong in intensity, i.e. not weakened by any admixture of blue or grey. Or that shadow is almost neutral, slightly greenish but not intensely so, and fairly light—about No. 2.

This way of analysing and noting colour is, of course, very useful if you want to paint from your drawings. The study of clothes on a chair on p. 64 (Fig. 57) contains written colour notes and was actually used in a painting. Sometimes a method of association will be found useful when trying to describe subtle colours. Anything which brings the colour to mind will do, such as 'coffee-brown' or 'light sand'.

You may find that the numbering of tones is too diagrammatic a device, particularly if you are the kind of draughtsman who naturally puts down tones rather than lines. In this case, your colour notes can be combined with scribbled indications of relative tone, as in this drawing.

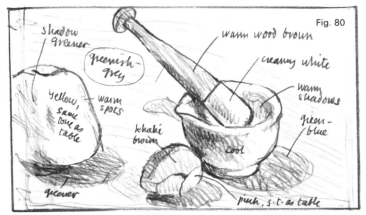

Fig. 80

The second colour plate on p. 88 (Fig. 78) shows an exercise designed to make one more aware of very subtle changes of colour, and particularly those from cool to warm. Take any natural object—such as a flower, a fish, or a prawn—which has tender, subtle and varied colours. Mix up and put down as accurately as you can, on a piece of white panel, a series of colour patches, disregarding shape and drawing completely. Try, though, to keep the size of each little patch in its proper relation to the others.

Each colour change must be mixed separately, and placed on the panel as a flat patch. Thus a smooth gradation, say from a pink to a red, or from a pink to a darker, greyer pink, has to be translated into a series of separate touches. If the subject is very small, your colour study of it may well be enlarged.

Cool and warm colours

The last exercise should help you to distinguish between very subtle distinctions of cool and warm colour, but perhaps a little explanation of these phrases might be helpful.

Most people will be familiar with the idea that reds, oranges and browns are warm, while the cool colours belong to the blue end of the spectrum. But we can talk of a warm blue (tending, that is, towards violet), or a cool green (tending towards blue), and certain colours will be, so to speak, balanced in the middle and neither cool nor warm except in relation to other colours.

So these terms are to some extent relative; and this is particularly the case with greys and neutrals. You probably know the experiment whereby an absolutely neutral grey can be made to look either warm or cool, according to the colour it is put against. If not, try doing this with flat squares of colour.

Fig. 81

In my opinion, a sensitivity to relationships of warm and cool is one of the most important factors in the development of a colour sense. I cannot put forward any other specific exercises that will help you here; it is largely a question of looking hard, and being aware of the distinction.

It will help, perhaps, to paint some subjects that contain very refined gradations from cool to warm—the mushrooms on p. 56 (Fig. 49) and the prawns on p. 88 (Fig. 77) are two examples, but many others will come to mind.

In the mushrooms the range of almost neutral colour goes from a warm ochre and an almost violet pinky grey to an ivory white, and on the cool side, to a bluish pale grey. Prawns contain an equally subtle range, from orange-pink to cool violet and blue-pink lights, as tender as the gradations on a rose petal.

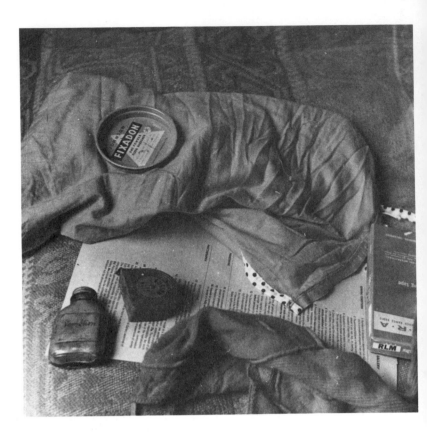

Fig. 82

Variety of colour within a limited range

This is an exercise which helps one to realise something of the variation which is possible within a limited range of colour. It consists of making a random collection of objects which are all, say, red (though the colour could be limited to any other, of course), and making a study purely from the point of view of the colour differences. The result can be almost abstract, in that the identity of the objects used is not at all important—only their value as colour.

Go round the house finding red things. These may be books, boxes, pieces of material, clothes, fruit—anything, so long as it comes within the red range, which in practice can mean anything from nearly orange to nearly purple. Throw this armful of

Fig. 83

things that you have collected down on the floor. As long as the full range of colour is visible, it will be a good thing to arrange it as little as possible. A photograph of such a collection is shown on the previous page (Fig. 82), and the study that resulted from it is on this page.

As you see, the shapes have all been reduced to simple flat areas of paint, to allow the colour changes their full value. But the size of each colour shape has been rather carefully adhered to, as has the exact degree of intensity and warmth or coolness in the colour. Apart from that, it is practically an abstract painting —but one done from observation, and with a purpose; probably a better way of making an abstract based on still life than the usual rather arbitrary affair.

Tonal relations

The other factor which affects our sensibility to colour, far more than is often realised, is the observation of subtle tonal changes. We can try to increase our awareness of this aspect by various exercises, as we have been doing with colour.

One of the things which makes the pictures of many beginners lack breadth and unity, and hence be poor in colour, is a jumpy quality in the tone of the picture. It is very easy, for instance, to exaggerate a light tone which occurs in the middle of a dark area. If this happens, it will probably look wrong in colour too. It is surprising how often poor colour can be traced to lack of tonal unity of this kind.

You will often find that a whole area in your picture is made up of tones that are very similar, each having slightly different colour values. If you get into the habit of squinting at your subject through half-closed eyes, you will find that these similar values come together to form one broad area of tone. Now look at your picture in the same way. Does it work there, too?

Look, for example, at this diagram. A is actually of exactly the same value as B, but because it is surrounded by darks it is easy to misjudge its lightness. Half-close your eyes, and the problem is somewhat simplified.

Fig. 84

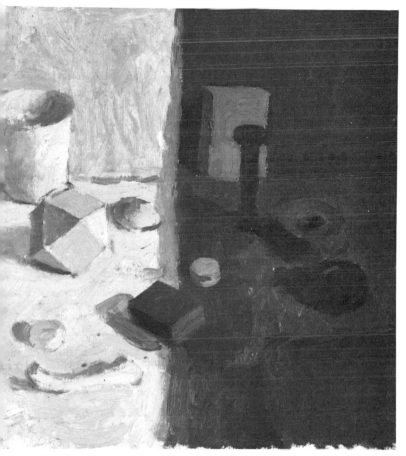

Fig. 85

We can take this a little further by setting up a simple still life in which we alternate big areas of dark objects against a dark ground, and light ones against a light ground. Any objects will do—go round the house, as you did for the other painting, and choose them solely for their tonal value. Keep your painting as simple as you can, putting in flat patches of paint without bothering very much about the exact drawing of each thing. But don't leave anything out! The whole point of these studies is that we are not trying to make nice pictures—they are helping us to observe; and, as I have said before, the best way to do this is to accept everything that happens to be in front of your eyes.

While making this study of light and dark areas, you may have noticed an important fact. This is that the range of tone created by the light falling on the object and making shadows, is likely to be greater in a light-coloured form than in a darker one. Thus, the change of tone from light to dark in Fig. 86 is greater than the similar change in Fig. 87.

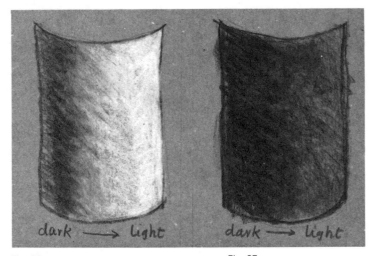

Fig. 86 Fig. 87

I point this out because many beginners are inclined to exaggerate modelling from light to dark in an unconscious attempt to 'make things look round'. This is a trap which it is very easy to fall into. Solidity is, as a matter of fact, much more likely to result from a careful attention to the drawing, and the exact relationship of planes of tone and colour, rather than from over-modelling. There is always something unpleasant about exaggerated modelling from light to dark, particularly when it is associated with strong colour.

As an additional exercise in the use of tone and modelling, try using simple forms like cardboard rolls or tubes, boxes, and other solid objects, painted with a matt grey colour (poster colour (paint) will do). If you set them up on a plain surface, something like the example opposite (Fig. 88), you will have a subject that

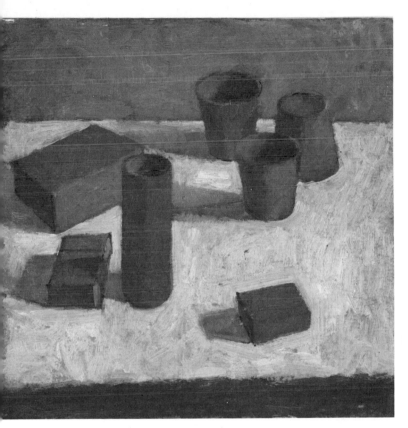

Fig. 88

combines two areas of study, both important—the examination of tonal changes within a limited range, and the exact placing of units in relation to one another. When the objects are isolated from each other, as in this example, the spaces between become very important in judging relationships. I have tried in the diagram over the page (Fig. 89) to express something of the way that the eye behaves in this attempt to relate shapes across areas of ground. It is essential to check both vertically and horizontally, because you must know where your horizontal is going to be. This is dictated by the position of your canvas, and your direction of vision, in relation to the object painted. If there is the edge of a table visible, make up your mind how near to a horizontal this is. A vertical may be found in the subject.

Now all other directions can be related to these two fixed ones.

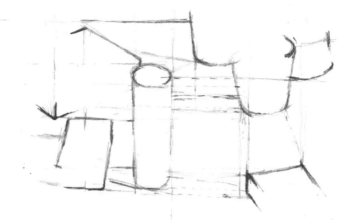

Fig. 89

The dotted lines in the diagram above show how this is done, and how the eye may move from one point to another, judging angle and distance.

Any line or mark on the ground which connects two objects is important, so don't leave these out.

The little 'all-over' composition of mushrooms on p. 56 (Fig. 49) can be related to this approach. In fact, while I was doing it, I was making these checks and measurements in a relatively instinctive way, but there is no harm in carrying out some studies in which it is done quite consciously and deliberately. What starts as a self-conscious and reasoned act becomes, with practice and repetition, so much a part of the working method as to be taken for granted.

Fig. 90 Plan of canvas in relation to table, and resulting pictures

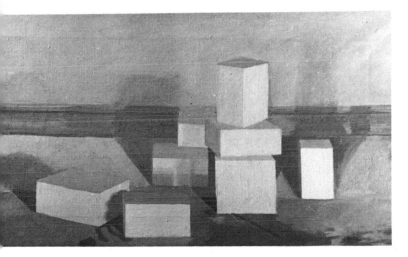

Fig. 91

I should, perhaps, add to this in passing that the position of your easel or drawing board—the angle of it in relation to the object—can make a very big difference to the way things are seen. In the first of these two drawings the canvas is parallel to the front of the table; in the second it is at an angle.

The same approach can be used in an all-white still life. Whereas the previous one could be painted as a monochrome, in a white picture colour, paradoxically, is going to play an important part, because the planes of white objects—such as those in the student's still life shown above—are extremely varied and subtle. So this exercise links up with our exploration of warm and cool colour.

So-called neutrals, like the greys of the shadow planes in these rectangular blocks, can be full of colour. The white can turn to blue-grey, violet-grey, green-grey, according to the angle of the plane and the reflections from neighbouring areas. A possible exercise would be to stress these colour tendencies, so that a cool grey is put down as a frank blue, and so on.

Here, however, we are getting into the realm of intensified colour, and eventually of invented colour, and in this book we are dealing essentially with observation rather than invention.

In any case a painter is, I believe, more likely to use colour freely and inventively if he has gone through the discipline of exact observation. I know this would be denied by many people; but in my experience of teaching, those students whose use of colour is based mostly on abstract and theoretical exercises do not seem to produce such interesting, odd, or individual colour. I think their use of colour is often inclined to be a little arbitrary, or merely decorative. When there is no reason why the colour of a passage should not be altered from green to violet, the standard by which the choice is made is merely 'I like it like that'. When the painter is working on a basis of limited experience, this does not seem to be enough.

Or a quite unnecessary rule-making can creep in; so that, in the absence of any other reason for using colour, a mechanical concept of colour 'coming forward' or 'going back' is applied, regardless of the facts or, indeed, the needs of the picture.

This business of colour movement has taken the place, as an academic cliché, of the old reliance on perspective and 'correct drawing'. The idea, which many students get, that cool colours—blues—always go back, and that warm ones—oranges and reds—always come forward, can be tested in a simple way. Take two empty tins, packets or other containers; paint one blue and one orange, using flat poster colour. Make sure that the intensity and tone of each is about the same. It wouldn't be fair to use, for example, an intense prussian blue and a dull pale orange.

If you put these coloured objects on a table and move them about, you will very easily find that it is their relative positions in space that make one come forward and the other go back—not their colour.

For instance, if the blue one overlaps the orange one, as in the drawing here (Fig. 92), quite clearly no colour in the world is going to make any difference to their position in space. Yet one can still find people who will let theoretical considerations of this kind over-ride what they let their eyes see. I remember a student who was painting a small still life in which a dark object came about nine inches behind some lighter ones. He insisted on painting this dark thing lighter than it was, because, as he said, 'it was further back'. I am afraid that his ideas about 'creating space' were simply preventing him from looking at all.

Compare this sort of dogmatism with the truly inventive use of colour and space that one finds in a painter like Bonnard. He is the supreme example of the truth of Cézanne's profound statement: 'There is a logic of colour; the painter owes obedience to

LIBRARY/LRC
OUACHITA TECHNICAL COLLEGE
P.O. BOX 816
MALVERN, ARKANSAS 72104

blue orange

Fig. 92

this alone, never to the logic of the mind. If he surrenders to the latter he is lost. He must always follow the logic of his eyes. If he feels accurately, he will think accurately. Painting is primarily a matter of optics. The matter of our art lies there, in what our eyes are thinking.'

Bonnard thinks with his eyes all the time, he is always prepared to be surprised by the visual fact that his eyes, without preconception, feed on. A foreground may be bathed in a pale bluish colour, a background full of complex warm hues. He intensifies, uses apparently arbitrary colour, but always on the basis of the thing seen.

Bonnard himself said 'The thing must start with a vision, with a moment of excitement. After that, you study the model—or memorise it . . .' Most of his pictures were, in fact, painted away from the subject; scribbled notes and memory reconstructed it. (I think, however, that many of his still lifes were as much painted 'on the spot' as Cézanne's.) I have heard that sometimes he would paint with his back to the subject, turning round and studying it when he needed to.

I have been writing in this book as if every still-life painting was

101

done with the artist glued in front of his subject, but this is not necessarily the case, and we should be aware of other possible ways of working.

The use of memory, rather than of direct perception, can make one concentrate on what is essential. Degas once said that if he ran an art school, he would put the model on the top floor and the students on ground level—if they had to run up five flights of stairs every time they wanted to check their observations, they would have to look really hard to memorise the important things.

It would be interesting, as an experiment, to paint a still life in this way—not necessarily with flights of stairs between you and your subject, but with your back to it, or in another room. Use notes as well as your memory. This method of working will be a sympathetic one for the kind of painter who prefers to be at one remove, so to speak, from his subject. It should certainly prevent one from copying the subject thoughtlessly. But I would like to make a distinction here between copying and true observation. I think many people fail to see the difference, and have the idea that the only alternative to copying 'photographically' is in some way to 'improve on' the subject—to use it merely as a basis for a personal interpretation.

I have tried to show that a vigorous, thoughtful and exacting attempt to relate measurement, tone and colour, and to find harmonies and relationships through hard looking, can result in something creative that goes far beyond copying. We are bound in this process to emphasise the things that seem to us important, and are thus making a personal interpretation—but one which remains in close contact with the character of the subject.

That remark of Bonnard's that I quoted above, 'The thing must start with a vision, a moment of excitement', seems to me to go to the heart of this business of painting. Without this essential excitement, everything that we do is to some extent an exercise; and painting is a great deal more than a matter of setting oneself problems to solve. Exercises and projects can be useful as a way of developing the capacity to see, to widen the range of our sympathies, and thus be more attuned and ready to receive and deal with the vision or the excitement; they are still only means to that end. The last chapter, in which I have tried to suggest some of these means, must be understood in this context.

If one is able to start with that moment of excitement, then the subsequent stages, the way the picture is carried out, must grow out of it and must be, finally, a personal solution and a personal statement.

Acknowledgments

My thanks are due to the following artists and galleries for permission to reproduce pictures in this book:

ADAGP Fig. 5
Maxwell Armfield Figs 40, 71
Diana Armfield Fig. 73
The Ashmolean Museum, Oxford Fig. 70
The Courtauld Institute Galleries, London University Fig. 72
Gillian Curwen Fig. 91
Emmanuel College, Cambridge Fig. 69
William Gillies and the Scottish Museum of Modern Art,
 Edinburgh Fig. 52
Eliot Hodgkin Fig. 41
The Trustees of the National Gallery,
 London Titlepage and Fig. 2
Patrick Simons, Fig. 36
The Tate Gallery, London Figs 5, 16, 26, 47
Euan Uglow and Marlborough Fine Art Ltd Fig. 50
The Waddington Galleries Fig. 51
Kyffin Williams Figs 23, 30

Index